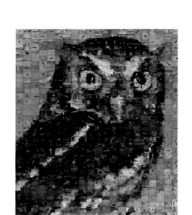

PHOTOMOSAICS

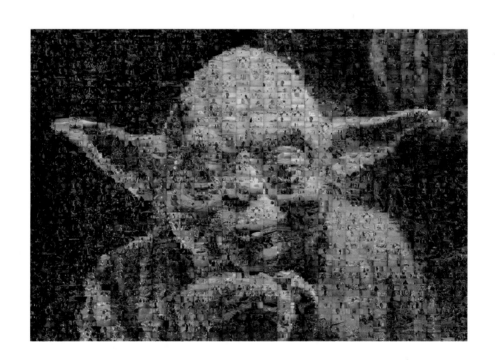

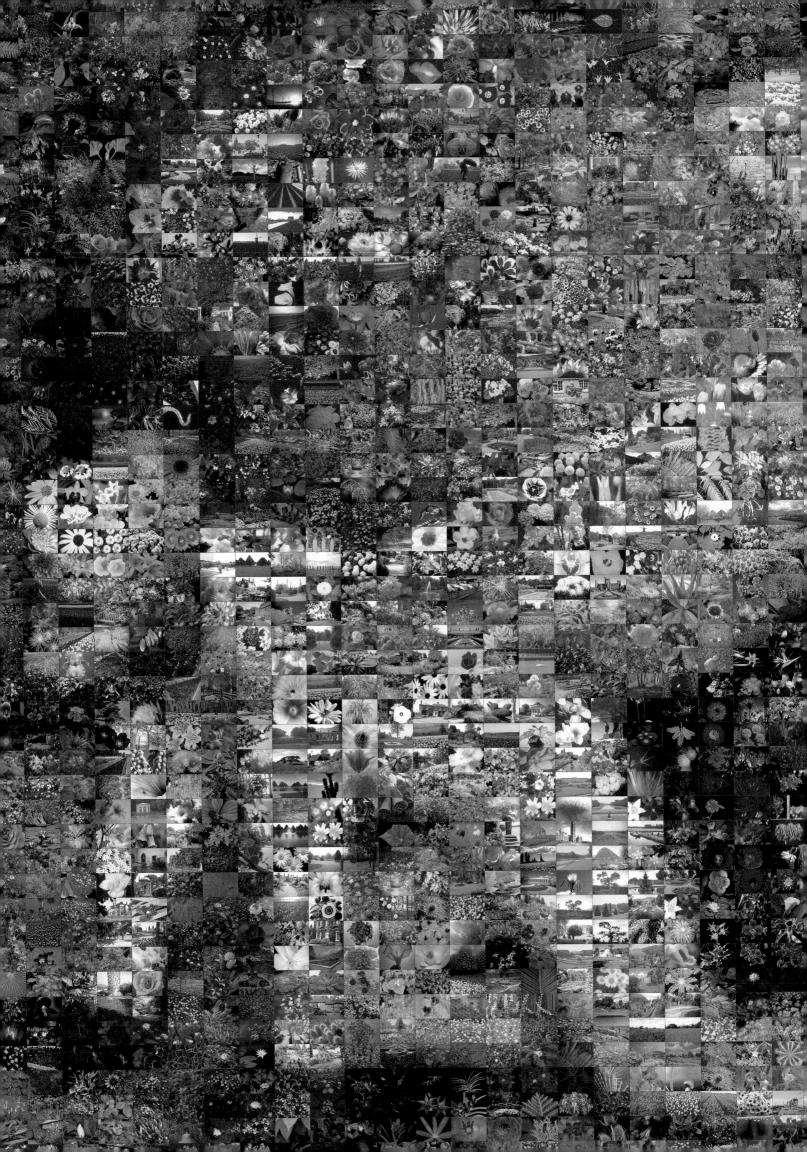

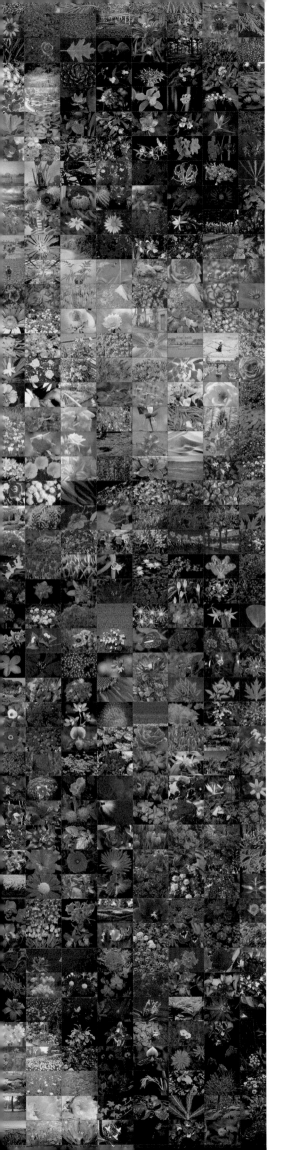

PHOTOMOSAICS

ROBERT SILVERS

EDITED BY MICHAEL HAWLEY

AN OWL BOOK · HENRY HOLT AND COMPANY · NEW YORK

Henry Holt and Company, Inc.
Publishers since 1866
115 West 18th Street
New York, NY 10011

Henry Holt ® is a registered
trademark of Henry Holt and Company, Inc.

Published in Canada by Fitzhenry and Whiteside Ltd.,
195 Allstate Parkway, Markham, Ontario, L3R 4T8

LIBRARY OF CONGRESS CATALOGING-IN-PUBLICATION DATA
Silvers, Robert, [date]
Photomosaics / Robert Silvers: edited by Michael Hawley
—1st Owl Books ed.
p. cm.
"An Owl book."
ISBN 0-8050-5170-8
1. Photomontage. 2. Image processing—Digital techniques.
I. Hawley, Michael, [date]. II. Title.
TK685.S55 1997 97-8721
779—dc21 CIP

Henry Holt books are available for special promotions and
premiums. For details contact: Director, Special Markets.

First Owl Books Edition—1997

Images were generated with patent-pending technology.

Designed by Lucy Albanese

Printed in Japan
All first editions are printed on acid-free paper. ∞

1 3 5 7 9 10 8 6 4 2

for LOVERS OF PICTURES

SEEING THE WORLD THROUGH PICTURES

It has been said that the most valuable prize the Apollo astronauts brought home was the famous photograph of our beautiful blue world, hanging like a fragile Christmas tree ornament in the empty blackness of space. It taught us to respect and cherish our home planet, and to care for its natural heritage.

—Arthur C. Clarke,
Colombo, Sri Lanka
August 1994

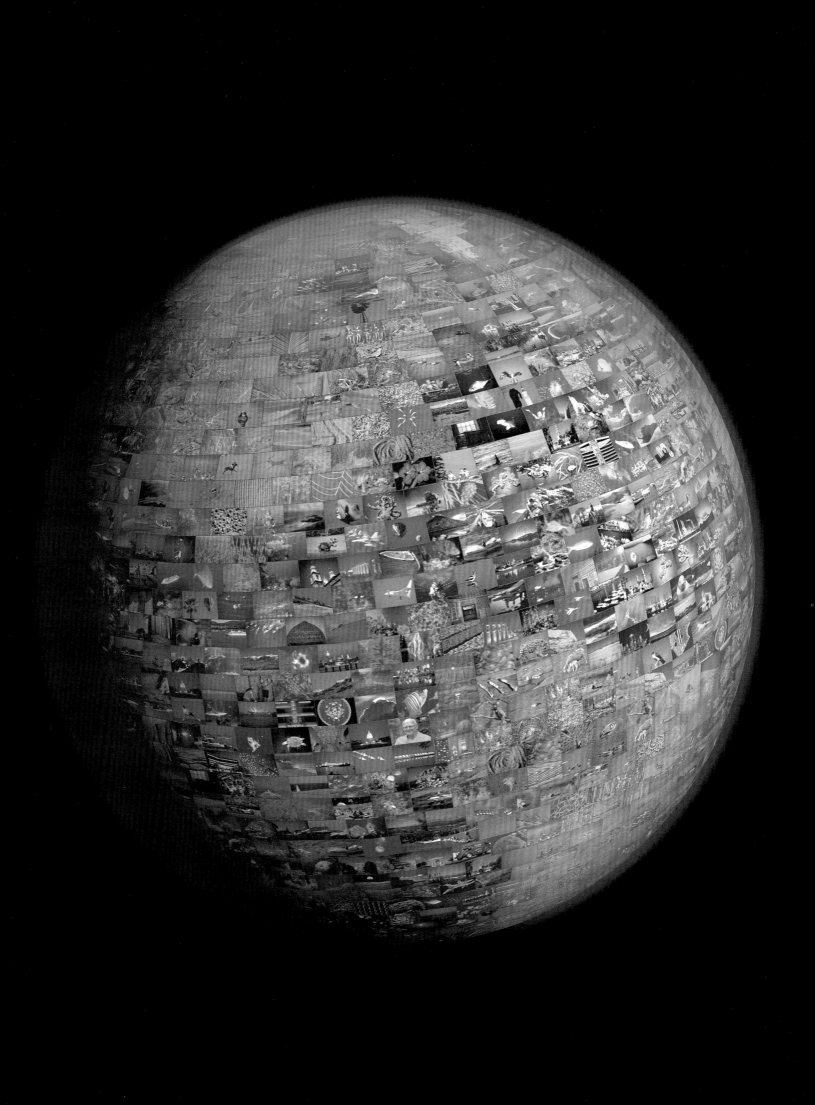

CONTENTS

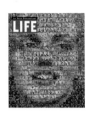

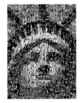

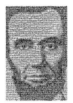

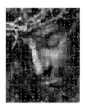

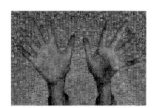

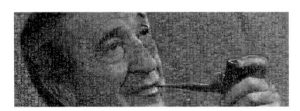

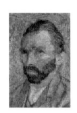

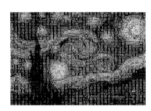

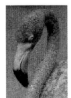

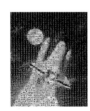

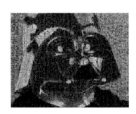

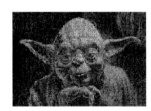

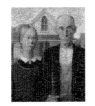
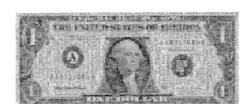
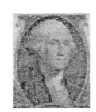
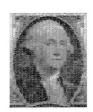
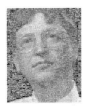
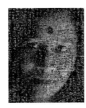
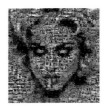
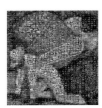
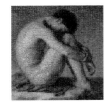
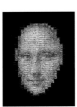
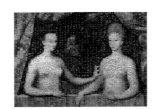
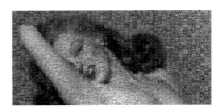
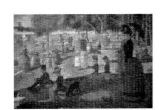
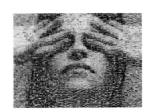

INTRODUCTION

Picture of Pictures

> Photomontage can say much more than the proverbial thousand words. Among the great inventions of the twentieth century, and still in its swaddling clothes, photomontage provides opportunities that have yet to be fully exploited.
>
> Photomontage is illustration by association, by juxtaposition, by subtlety. It collapses time and pulls extraneous elements together—an ideal instrument for storytelling and for the visualization of complex ideas.
>
> —*Paul Rand*

Paul Rand's words (written in 1996) are worth at least a thousand pictures. Rand was one of the world's great communicators. His logos (for companies like NeXT, ABC, UPS, and Westinghouse) are among the crown jewels of American graphic design, and his teaching and writing had the same brilliance and bite.

The power of a picture is hard to gauge, but when pictures are composed together the effect is multiplied, with the same sort of synergy that is built by rich musical counterpoint in a great fugue or symphony. Rand's observations hint at what this book is about: making pictures of pictures.

The idea of a picture of pictures isn't that new: Arcimboldo was painting portraits in the 1500s, with an obsession for using things like fish, game, and vegetables as elements. So why, after four centuries, was photomontage (for Rand) still in its swaddling clothes? The answer is: New technology was needed to help it grow.

Digital Impressions

The nature of pictures has everything to do with technology. This is as true for hand prints on the walls of Lascaux as it is for a child's fingerpainting or hi-tech computerized animations. Unlike singing, which uses innate tools and an invisible medium, people need external tools and visible media to make pictures. As new tools and techniques emerge, artists quickly start playing with them. The effect is often profound. The first mosaics, for example, were made from pebbles. Technology soon provided other ingredients—colored bits of

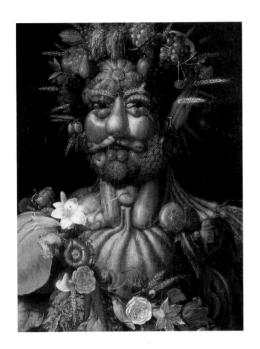

glass, precious metals, cut jewels, carved wood, glazed tiles—that could last for thousands of years.

Occasionally whole artistic movements spring up. It must have been a revelation to travel hundreds of miles to Paris to get a glimpse of Seurat's magical *Grande Jatte*, but Pointillism and other forms of Impressionism represented a small step compared to the impact of photography, audio recording and transmission, cinema, and television.

And then came computers. Suddenly, it seems, the world looks very different when seen through digital eyes. Of course, people "draw" with computers, but this is not simply an extension of using a stick to scratch a picture in the sand on a beach, or a digital Etch A Sketch. People "paint" with computers. They "photograph" with computers. They "animate" with computers. Computers are emulating pencils and paper, brushes and canvas, cameras and film. Artists like to say that ideas matter more, but the impact of digital media on art is intense: It is now possible to shape and to share sounds, pictures, movies, sculptures, and more with a single tool. The brush is loaded not with paint but with bits, and the palette is as rich as the global internet. Photomontage has grown up real fast.

Origin of Species

The photomosaics in this book exemplify an evolutionary step into the digital domain. At the MIT Media Lab, Rob Silvers (then a graduate student) and I (a junior professor) had complementary passions for pictures. I launched a research project with one of the world's greatest photographic archives in an effort to create a vast digital picture bank and to explore its possibilities. All the elements—image computers, a vast collection of dazzling and inspiring pictures, and a diverse set of interests and energies in digital imaging—were in the air. In 1995, in a mid-April late-night flash, Rob began writing software to make mosaics out of the photographs. Photomosaics were born.

Rob had been especially inspired by the earlier work of Ken Knowlton, an extravagantly talented computer pioneer and artist. Ken invented a great variety of mosaic-like image renderings, creating software to fit elements like dominoes or seashells into an image. Rob was in the right place at the right time to combine and extend these techniques by using great photographic archives as fuel for mosaics.

Work is always play when you follow your heart, but after the first burst of ideas it became a game. What tricks could we think of to improve the image quality? How could the pictures be puzzled together faster? What clever ways could the little pictures be played off the big picture? Could photomosaics be more than two levels deep? Could they contain secrets? be interactive, or animated like television? convey powerful emotional impact? Where could we find more content? Where would we store it all once we got it? And what about copyright? or the role of the "artist" vis-a-vis the machine?

Some of these questions seemed to answer themselves, more or less. It was exhilarating to watch Rob follow the thread. The first mosaics were jagged ("aliased," in computer graphics lingo), but Rob found a clever way to train the computer algorithm to look inside the images during the matching process. That smoothed away the jaggies. There was also no correlation between tiles and subject, but Rob devised a way to embed descriptive content bits in the images so that not only did the photos fit together like jigsaw pieces, but so did the ideas: Blue skies were filled with birds and planes; water with fish; faces were made from people. Software moved from Silicon Graphics supercomputers to Intel personal computers. Gigabytes of disk space were gobbled up with collections and renderings. We strained the technology. In many ways, computers are still infants when it comes to pictures and sounds.

As the idea became known, commissions began to trickle in, quite unusual for a student in the throes of a thesis. Magazines like *Wired, Life, Geo,* and IBM's research journal wanted art to perk up their issues. Private individuals sought commissions. Each outside probe nudged the ideas a bit further.

This book contains the very first essays in this new genre. Photomosaics are a playful way to say more with pictures, and a fun way to make beautiful images that make people think.

—Michael Hawley,
Cambridge, Massachusetts
January 1997

PHOTOMOSAICS

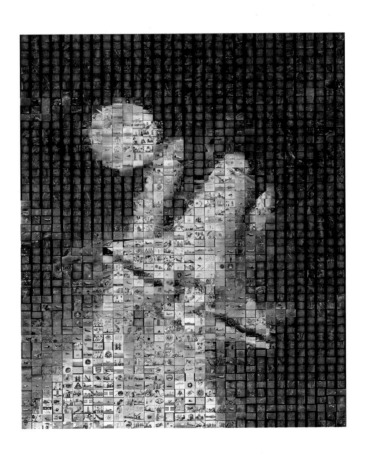

Owl

"I rejoice that there are owls. Let them do the idiotic and maniacal hooting for men. It is a sound admirably suited to swamps and twilight woods which no day illustrates, suggesting a vast and undeveloped nature which men have not recognized."

—Henry David Thoreau,
Walden

Owls' eyes are built for night vision. They're at least ten times as light-sensitive as human eyes. And their eyes are huge and on the front of their faces (like people's, not birds'), so they have binocular vision and depth perception.

Owls have the most sensitive hearing of all birds. Their ears are located at the edge of facial disks, round feather arrangements on their head. A little like the folds in our own ears, these disks collect and focus sound waves. In some owls, one ear is slightly larger than the other and of different shape so that they hear in 3-D: they can pinpoint the location of a sound.

Their ears and eyes work in concert—in fact, they are wired into the same part of their brain. It's as if owls see sound, or hear sights. Their eyes are so large and the coordination of ears and eyes so complex that there isn't room in their skulls for muscles to move eyes and ears independently: the whole skull pivots like a military turret. Their heads can turn more than 180 degrees in either direction: owls can see directly backward.

Owls fly silently. The front edge of their wings have fringes to muffle sound as they approach their prey: they're "stealth" bombers. Their toes are exceptionally strong, and each toe has a needle-sharp talon. The outer toes point out or back when seizing prey, providing the strongest possible grasp. A mouse rustling in the grass below is in serious trouble.

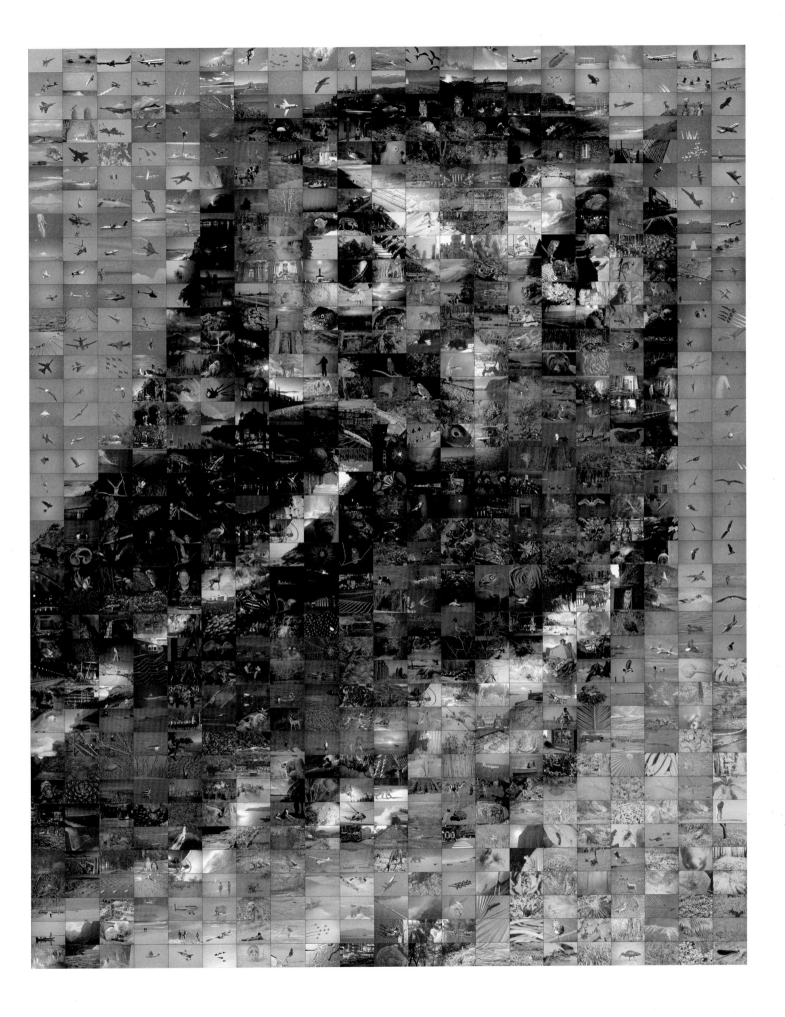

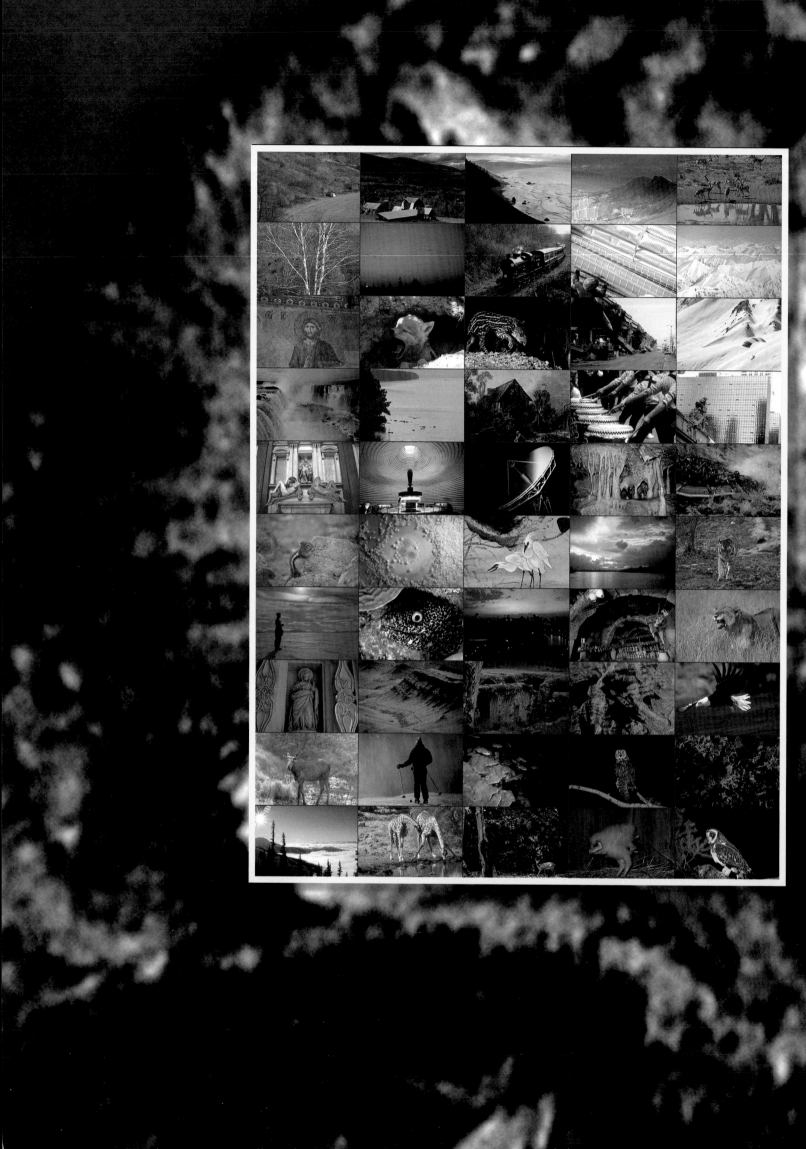

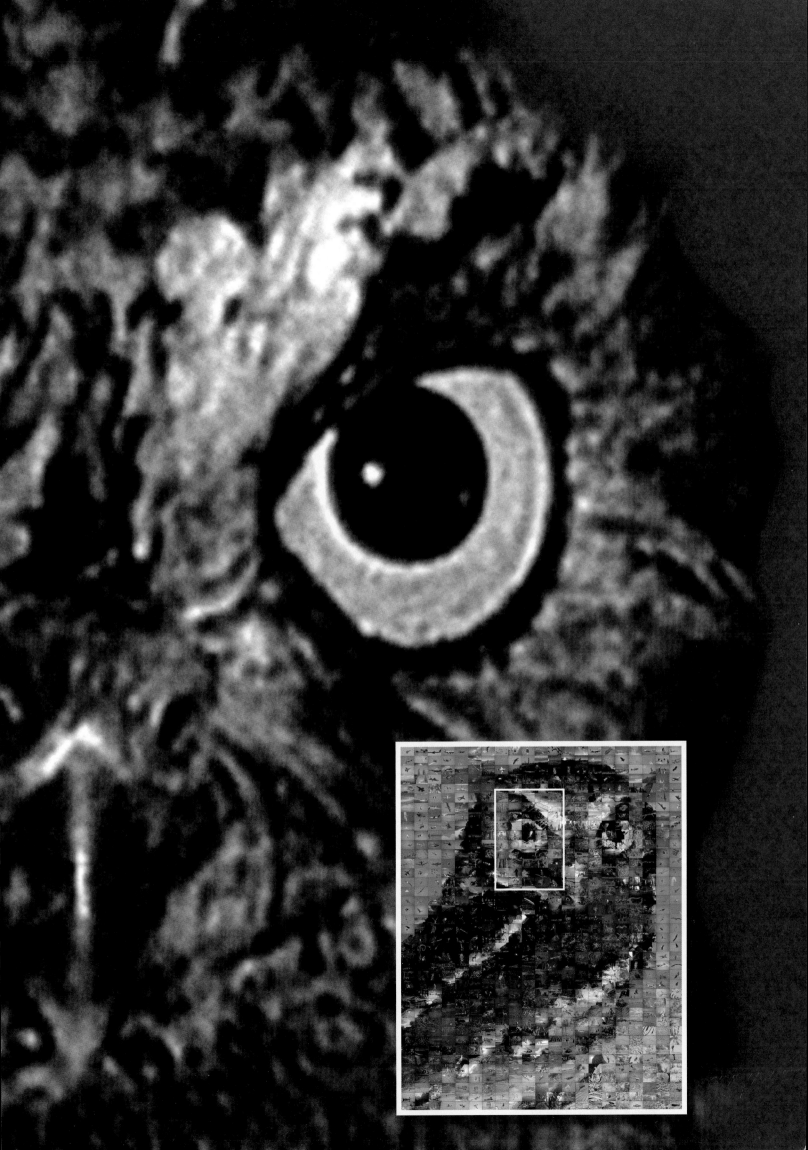

Marilyn in Life

In June 1996, *Life* magazine asked for a photomosaic to commemorate the magazine's sixtieth anniversary. After discussing various options, we decided on a "face," and the face chosen was Marilyn Monroe's. It would be her thirteenth appearance on the cover.

All of the previous *Life* covers of Marilyn are in the mosaic—as is the "mosaic" cover itself. And there is television actor David Cassidy as her mole, screen actor Sean Connery in her left eye, actress Mia Farrow near director Woody Allen, and, if you look for them, some of Marilyn's former husbands and lovers as well.

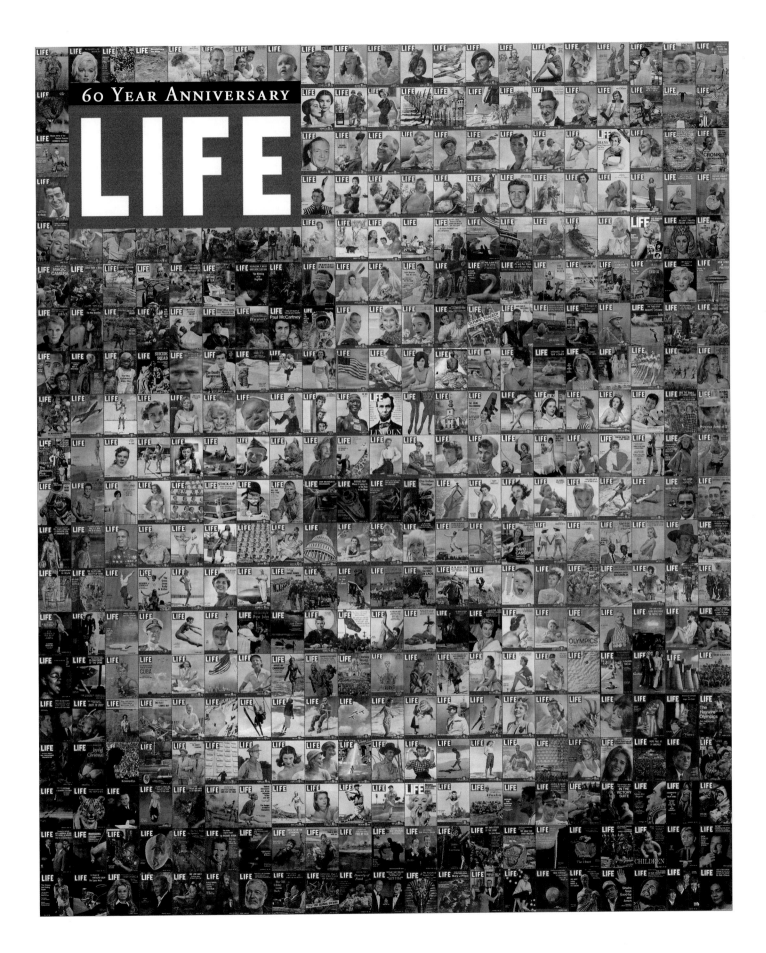

60 YEAR ANNIVERSARY
LIFE

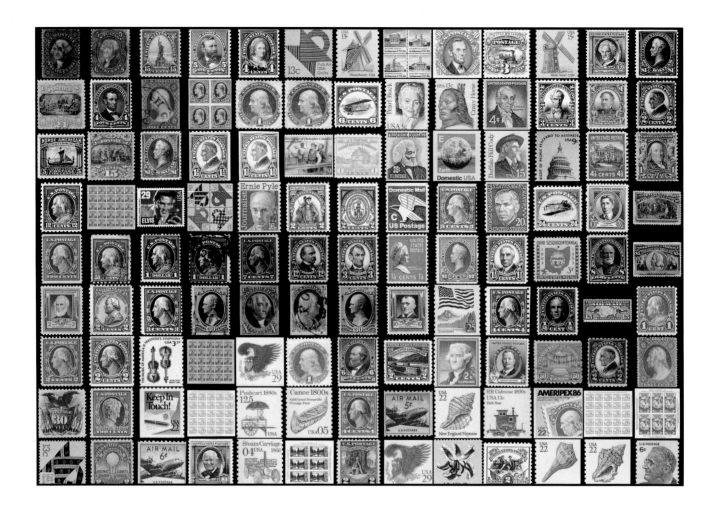

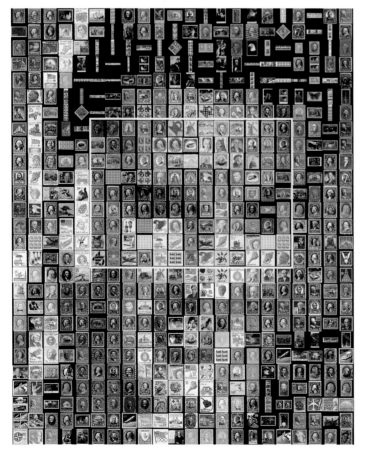

ELVIS PRESLEY

The Elvis Presley postage stamp on which this photomosaic is based is a story unto itself. In 1992, the U.S. Postal Service announced it would issue a commemorative "Elvis" stamp, and narrowed the artwork down to two choices: one of Elvis as a hot young rock star, one of Elvis during his 1973 Hawaii concert. It then put the question to America and distributed ballots nationwide. More than a million votes were cast, and the "young Elvis," created by artist Mark Stutzman, won. The stamp was issued in 1993 on Elvis's birthday, January 8, in a spectacular ceremony at Graceland. With more than 500 million printed, it is the top-selling U.S. commemorative stamp of all time.

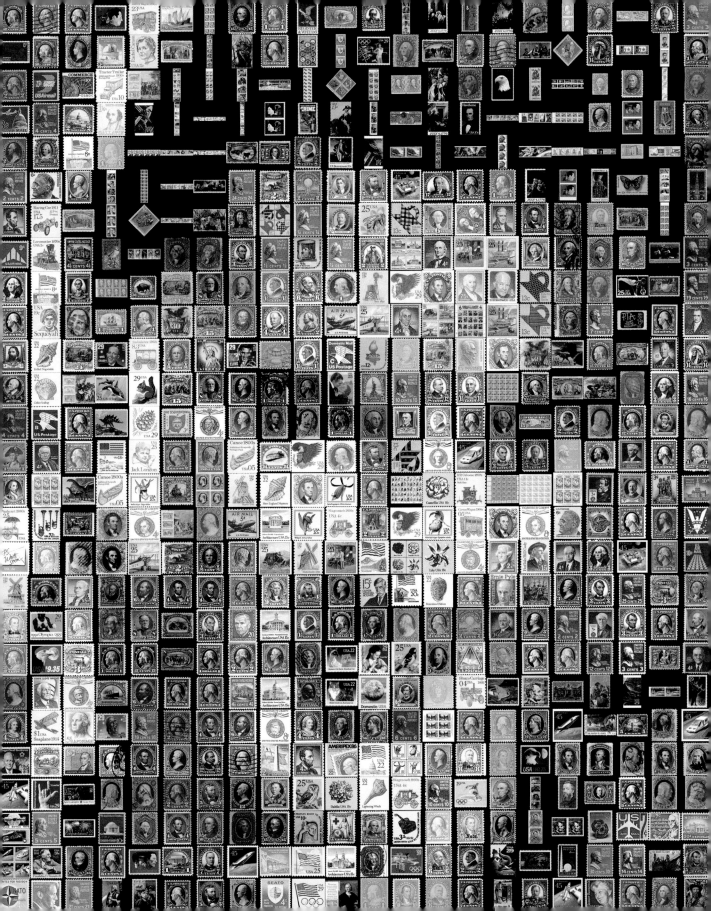

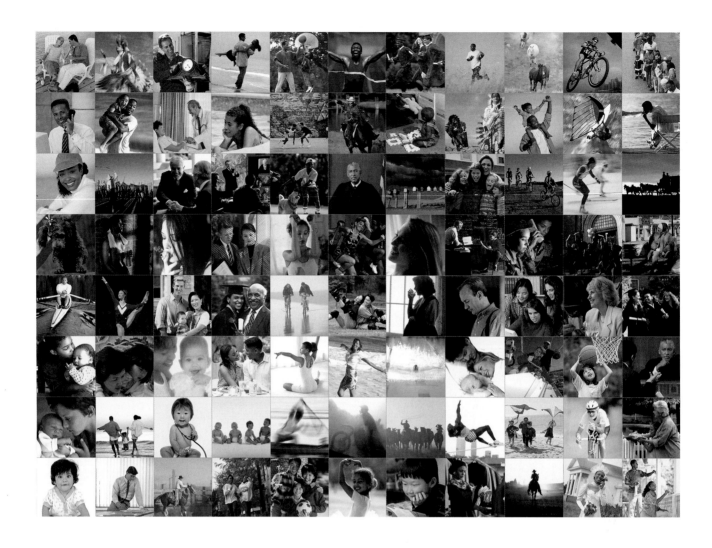

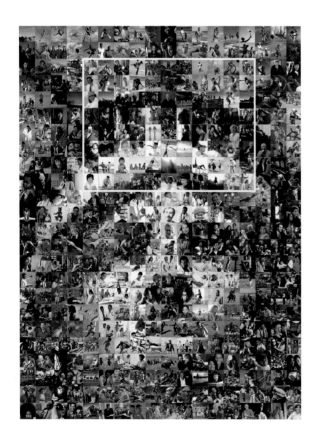

LIBERTY

"I will never forget that October morning in 1907 when I first saw the Statue. I was on a ship with sixteen hundred people, which had sailed from Italy two weeks before. There we were, my father, my mother, my two sisters, and my brother. We held each other closely and looked with wonder on this land of our dreams."

—Anonymous

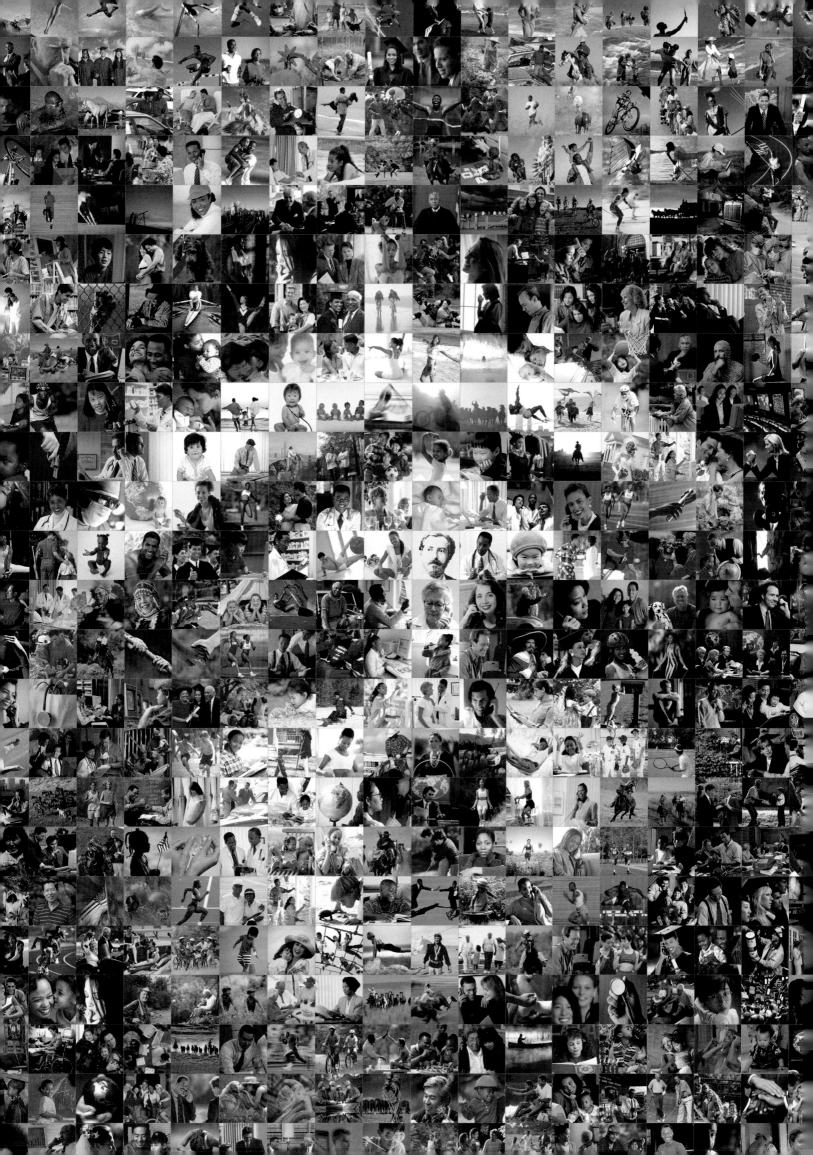

LINCOLN

Walt Whitman said his face was "almost as impossible to depict as a wild perfume or fruit taste."

Abraham Lincoln, sixteenth president of the United States, was the first American leader to be frequently photographed, just as the American Civil War was the first large-scale military conflict to be extensively documented with photographs: the fledgling art and science of photography made it possible to show the public not just images of generals and statesmen but horrifying pictures of dead and injured soldiers. In reviewing war photographs by Mathew Brady, *The New York Times* said the photographer had "brought bodies and laid them in our dooryards and along the streets."

This photomosaic, based on a Lincoln portrait by Mathew Brady, was made with Civil War photographs from the American Memory Project to help the Library of Congress celebrate its new National Digital Library. Along with portraits of hopeful recruits and resolute officers are images of carnage, suffering, and, below Lincoln's left eye, an assassin-to-be.

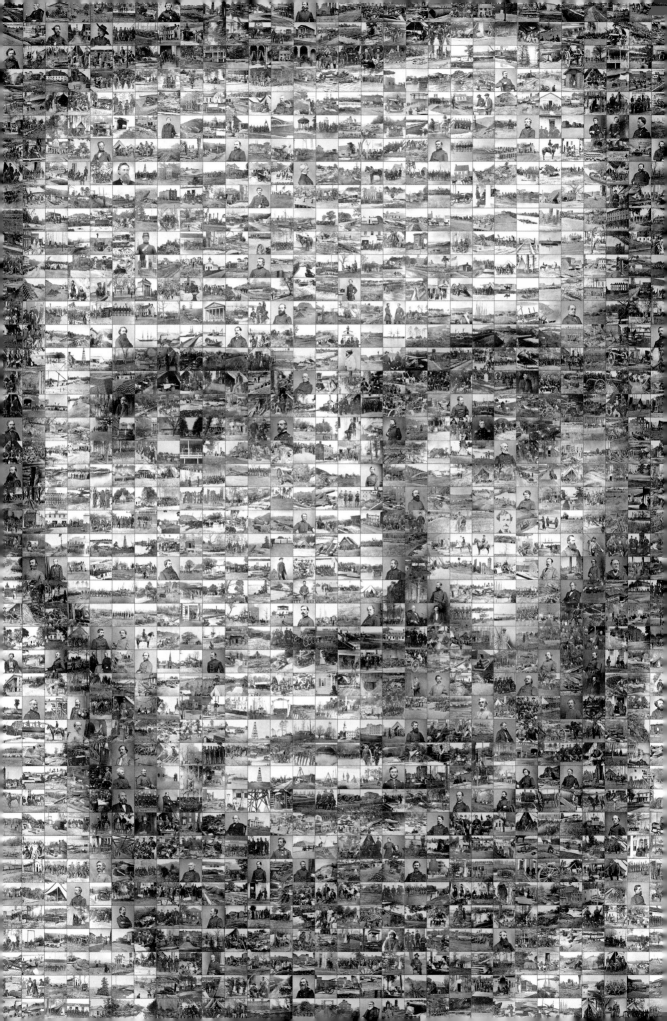

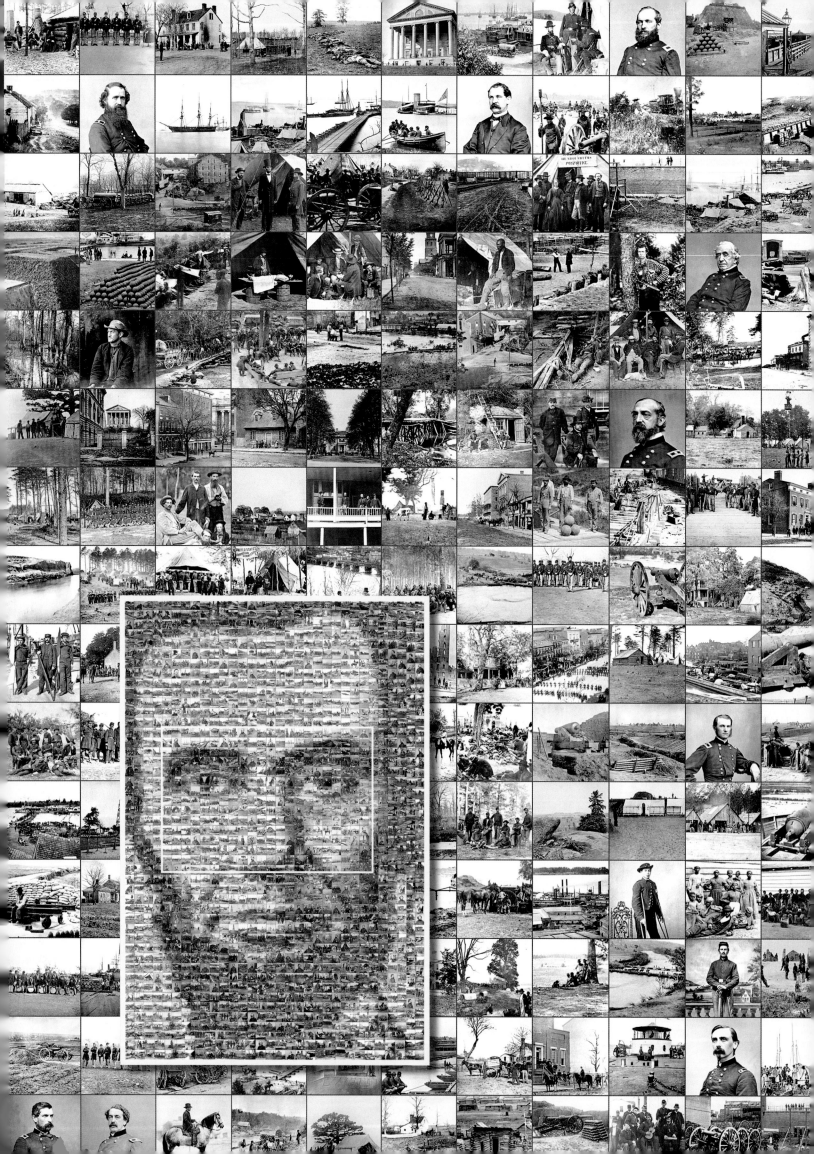

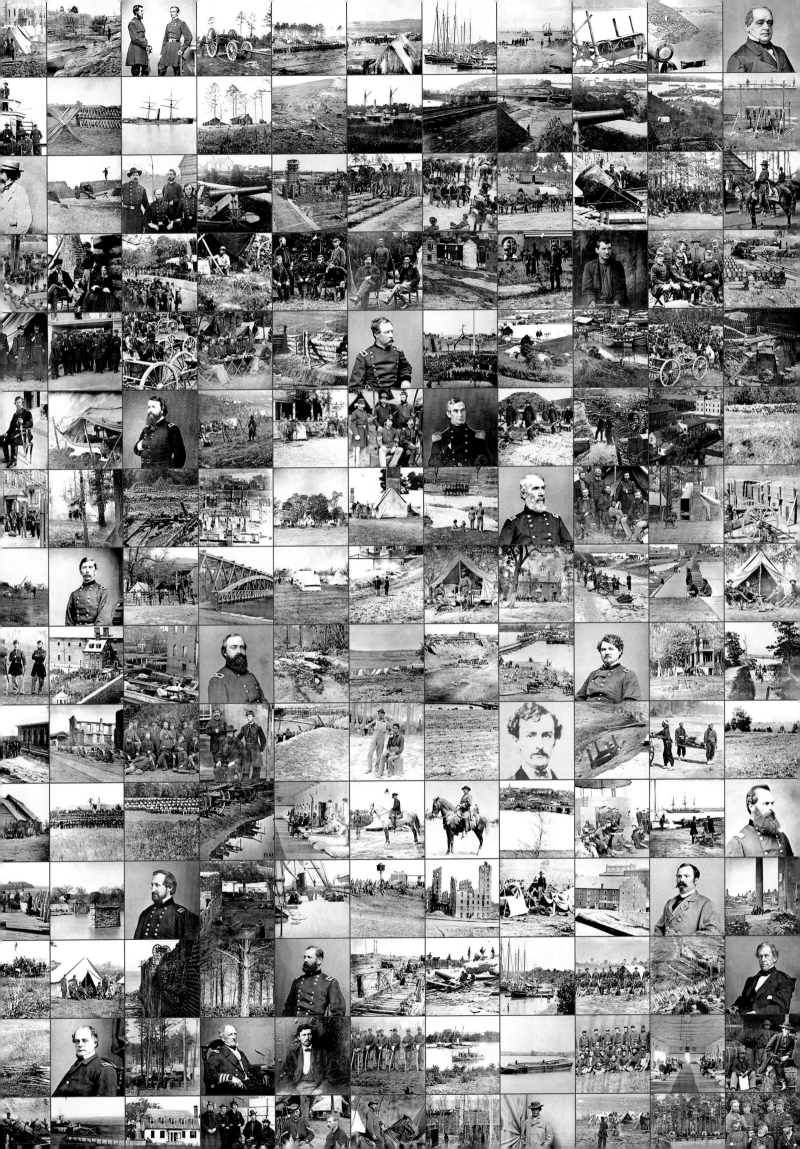

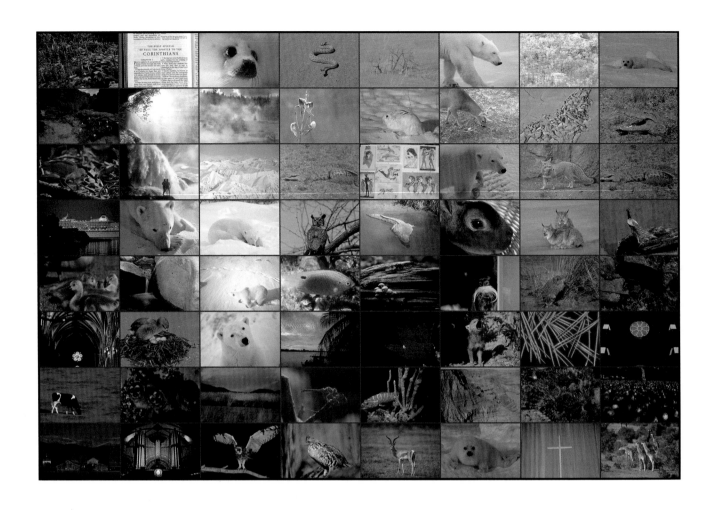

CHRIST

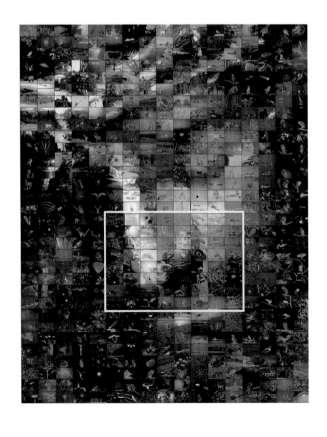

"And about the ninth hour Jesus cried with a loud voice, saying, Eli, Eli, lama sabachthani? that is to say, My God, my God, why hast thou forsaken me?

"Some of them that stood there, when they heard that, said, This man calleth for Elias.

"And straightaway one of them ran, and took a sponge, and filled it with vinegar, and put it on a reed, and gave him to drink.

"The rest said, Let be, let us see whether Elias will come to save him.

"Jesus, when he had cried again with a loud voice, yielded up the ghost."

—Matthew 27:46–50

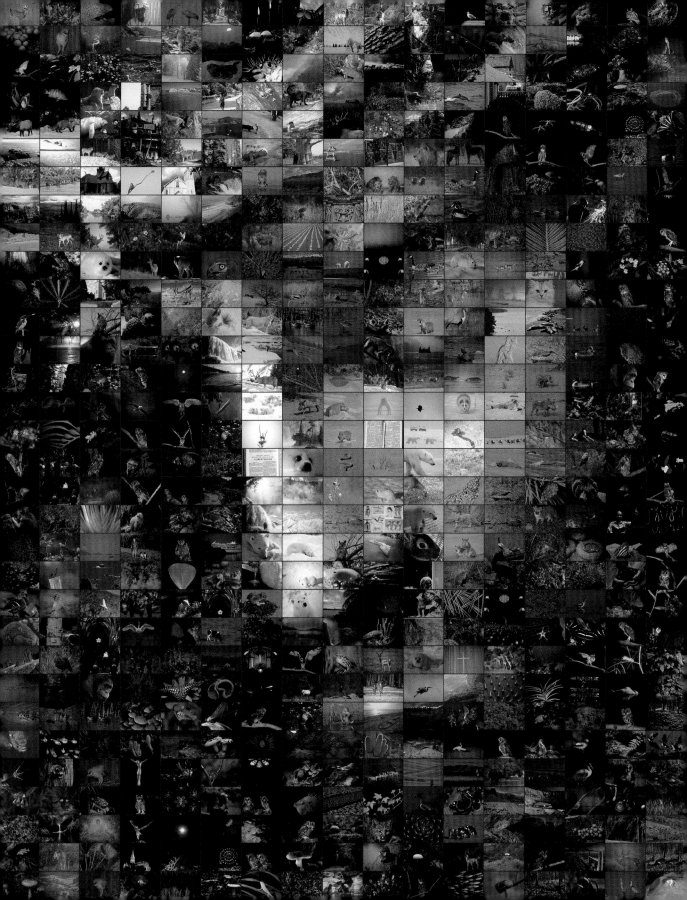

10/10

The title has at least two meanings: binary 1010 is equivalent to decimal 10, and this image was used in a poster to mark the first decade of the Media Lab at MIT, as well as to invite the citizens of cyberspace to reflect on the new digital renaissance by sending us their bits—including pictures and text—for a one-day celebration on 10/10/95.

The hands belong to former MIT student and violinist Julia Ogrydziak. She has wonderfully shaped fingers—very long and sinewy—and the idea to use the image of an artist's hands reaching out and feeling the future, to signify all of us reaching out to touch cyberspace, seemed exactly right.

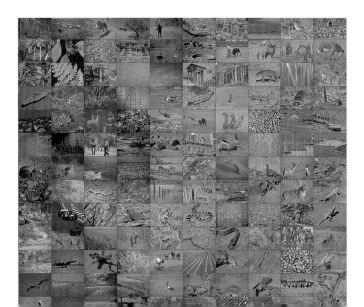

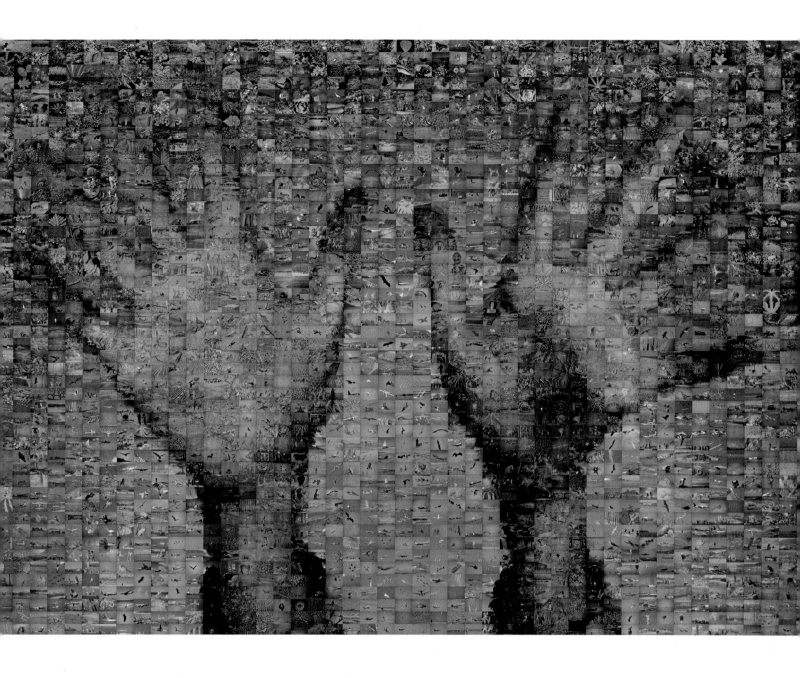
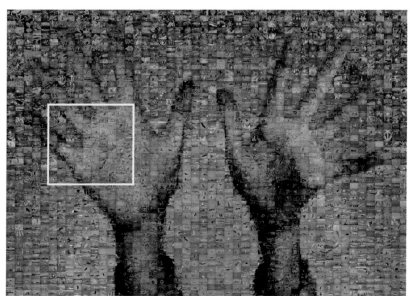

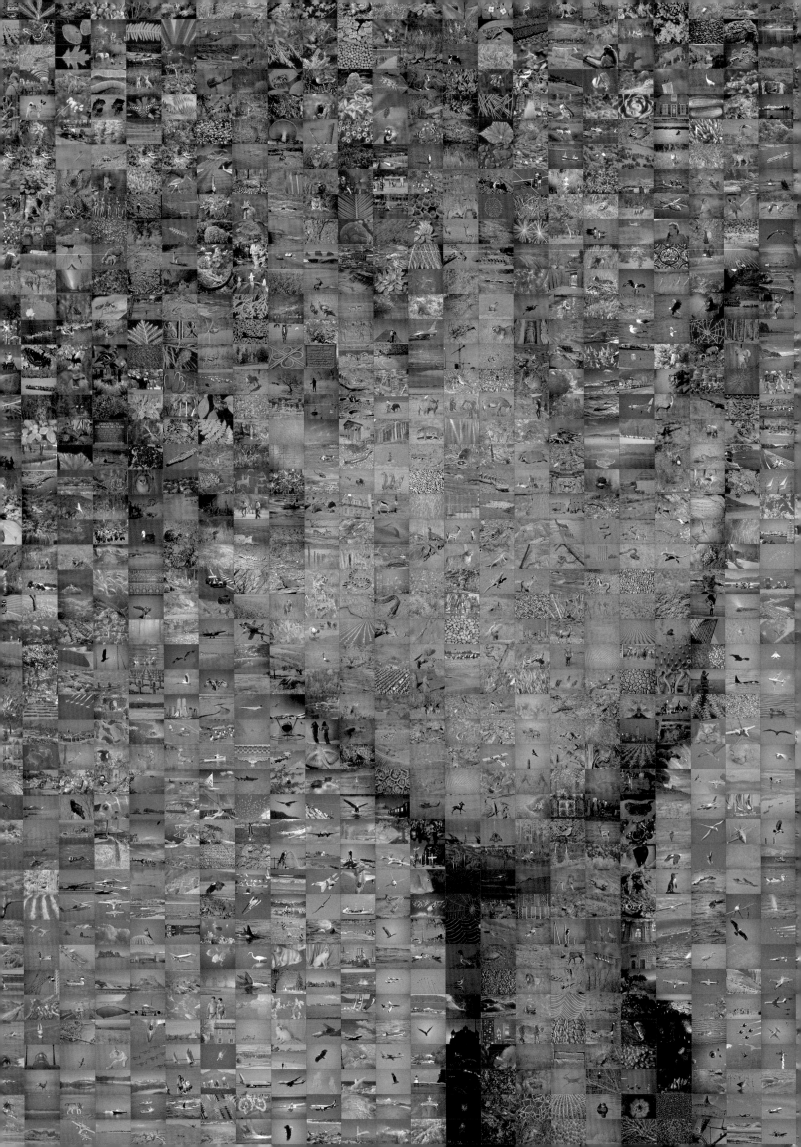

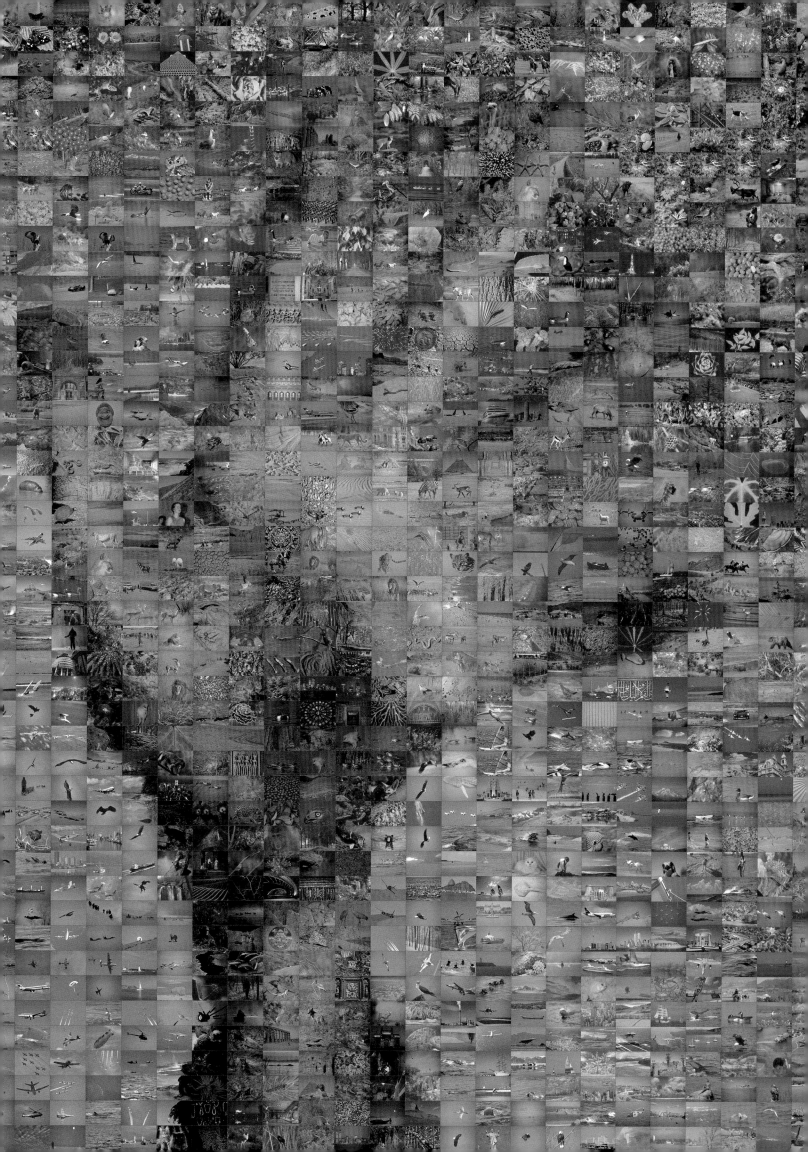

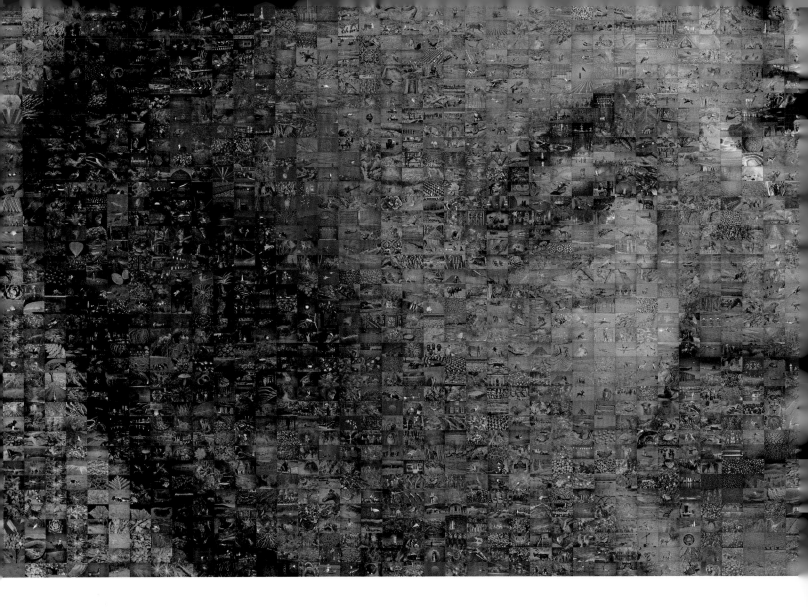

Jerome Wiesner

Jerome Wiesner (1915–1994) was a pioneer in the development of radar, president of the Massachusetts Institute of Technology, and science advisor to President John F. Kennedy. For decades Wiesner helped shape the science and technology policies of the United States. He was also the founder and visionary behind MIT's Media Laboratory, whose building is named in his honor. (One of the tiles in this photomosaic shows the building.)

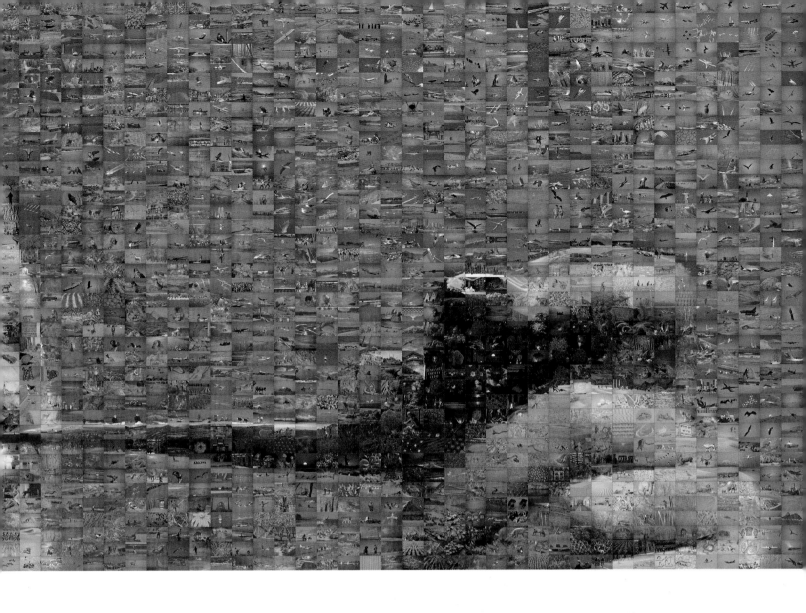

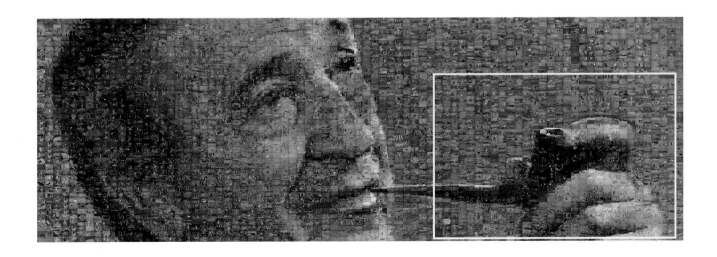

Overleaf: Detail of Wiesner's hand around the bowl of the pipe, as highlighted above.

Vincent van Gogh

"The more ugly, older, more cantankerous, more ill and poorer I become, the more I try to make amends by making my colours more vibrant, more balanced and beaming."

"The painter of the future will be a colourist, such as has never yet existed. Manet was working towards it, but as you know the Impressionists have already got a stronger colour than Manet. This painter of the future—I can't imagine him doing the rounds of the local dives, having false teeth and frequenting the Zouave brothel like me."

—Vincent van Gogh (1853–1890),
Letters to his Brother, Theo

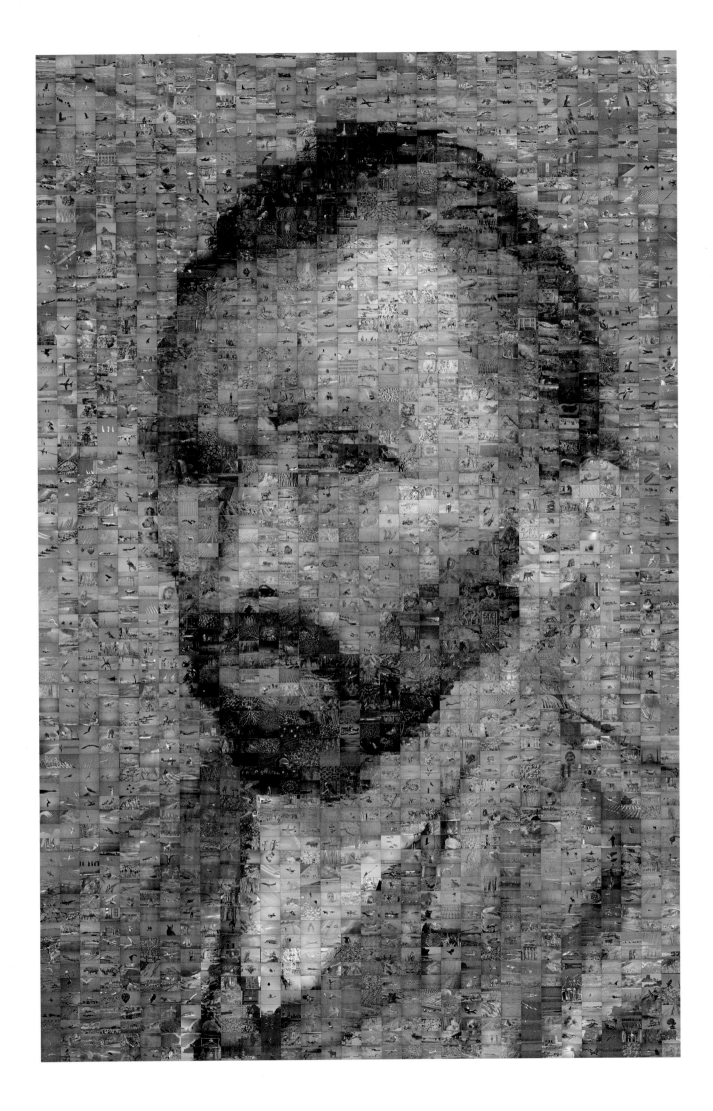

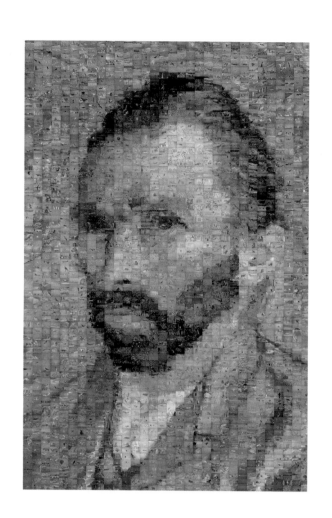

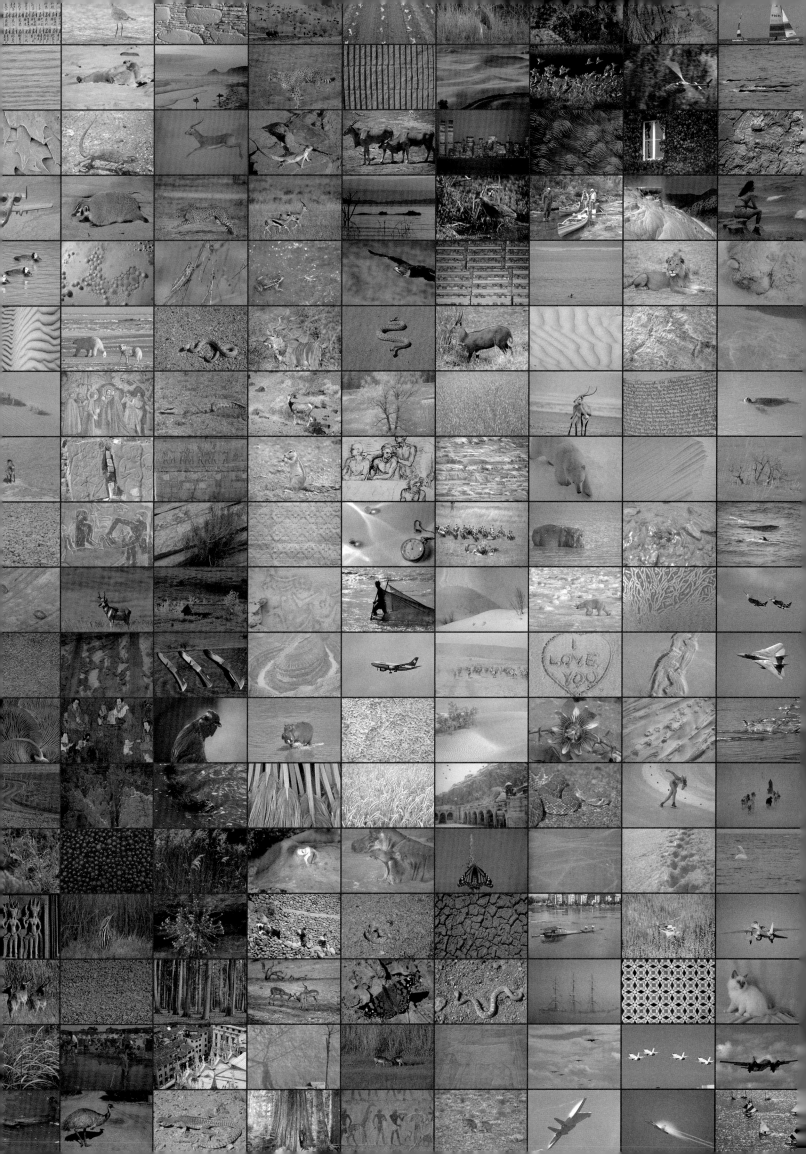

Starry Night

"I often think that the
night is more alive and
more richly coloured
than the day."

—Vincent van Gogh

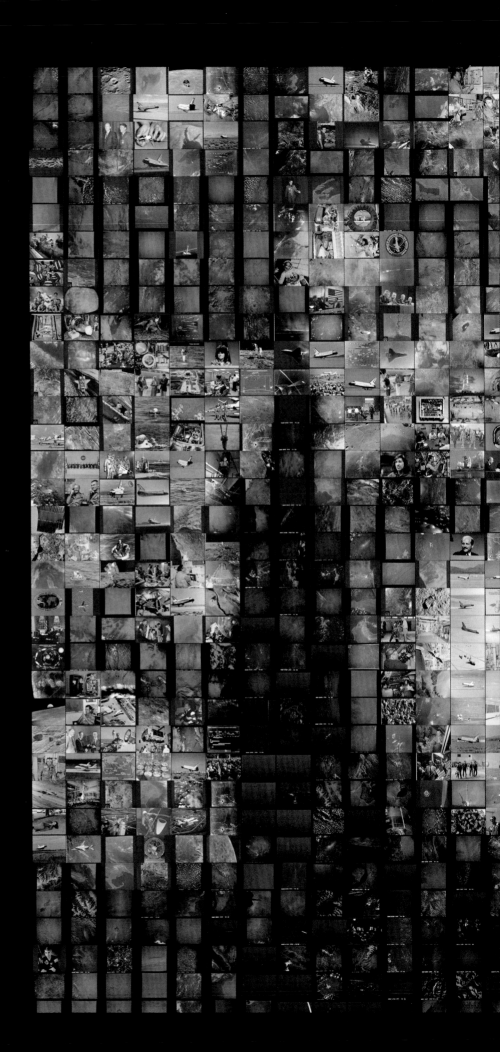

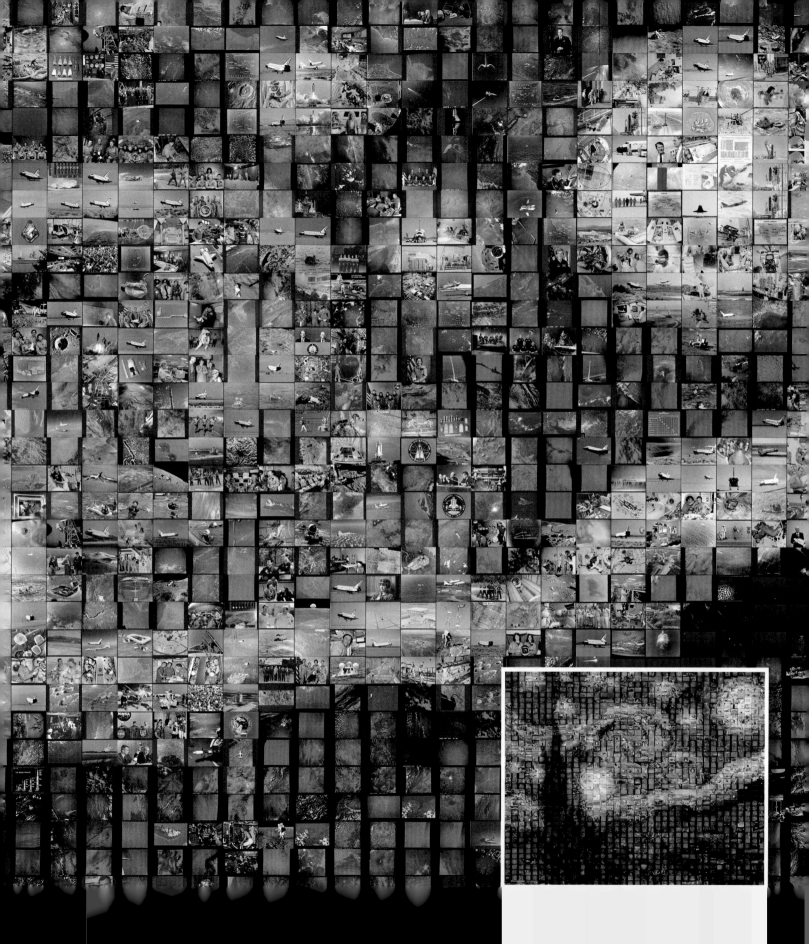

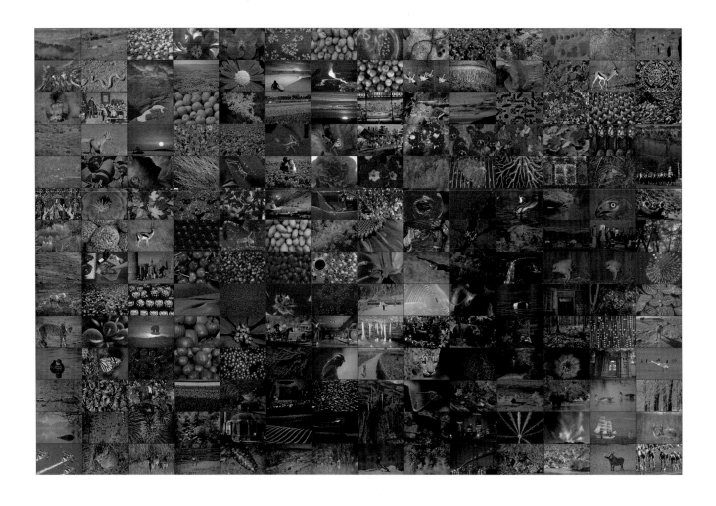

Flamingo

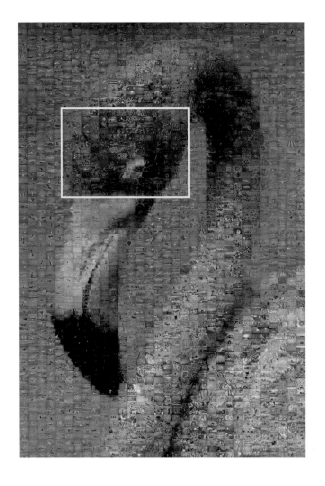

"Of course the Neverlands vary a good deal. John's, for instance, had a lagoon with flamingos flying over it at which John was shooting, while Michael, who was very small, had a flamingo with lagoons flying over it. John lived in a boat turned upside down on the sands, Michael in a wigwam, Wendy in a house of leaves deftly sewn together. . . . On these magic shores children at play are for ever beaching their coracles. We too have been there; we can still hear the sound of the surf, though we shall land no more."

—James M. Barrie,
Peter Pan

In nature, they may flock literally by the millions. In plastic, they were once the lawn ornament of choice. And in neon, they adorn countless hotels and motels, including the Pink Flamingo shown in one of our tiles.

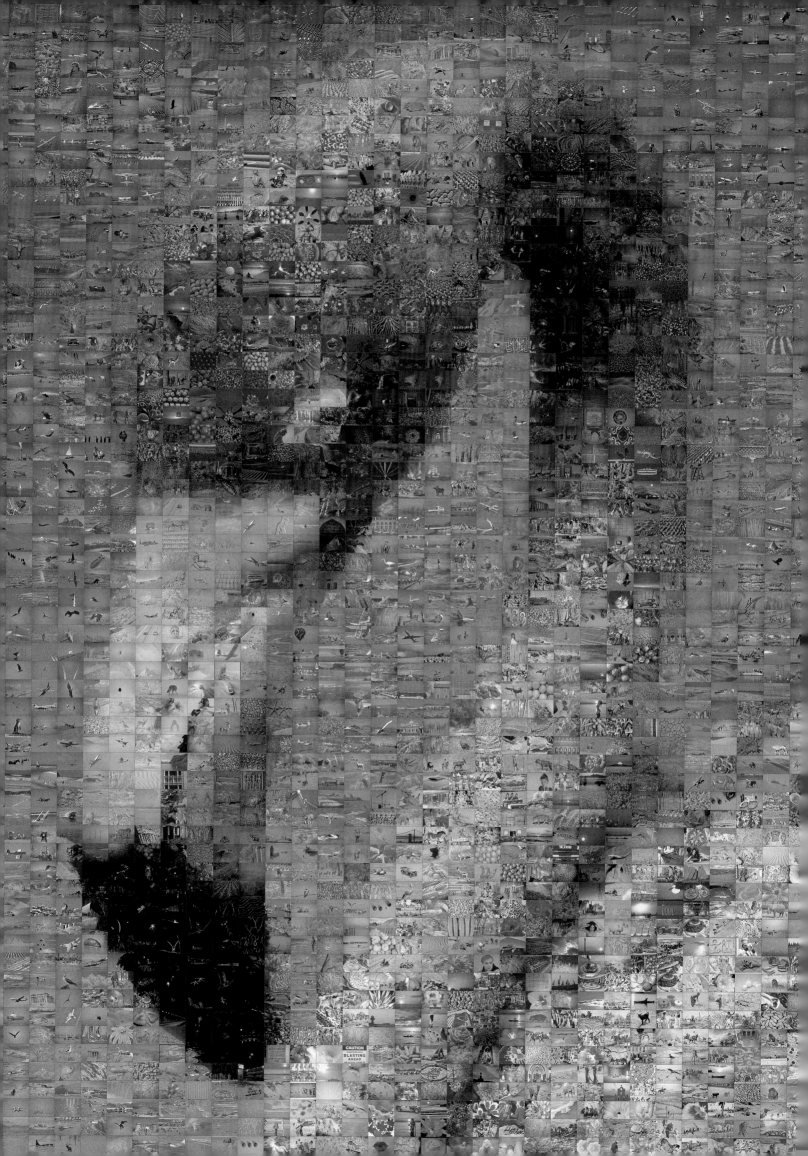

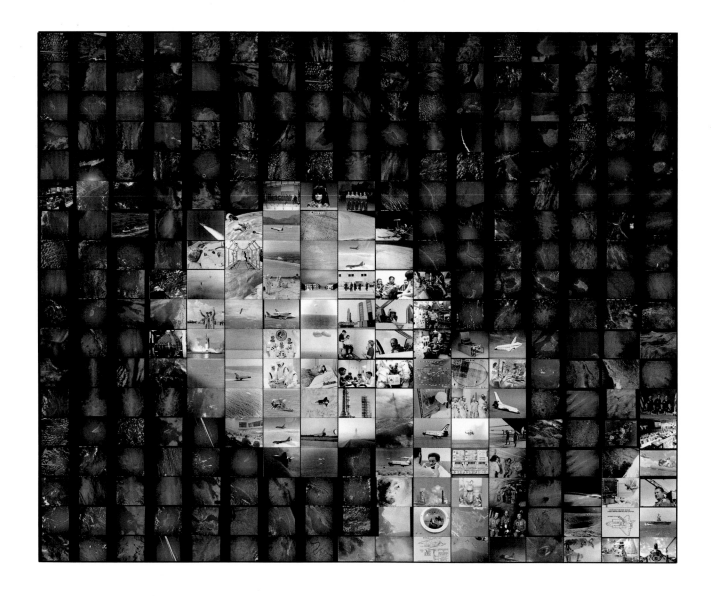

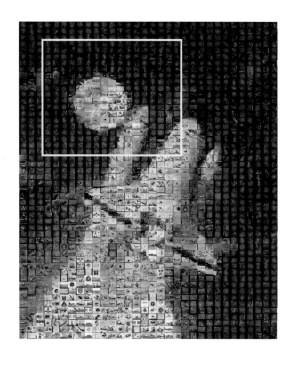

Shuttle

"We choose to go to the moon in this decade and do other things not because they are easy, but because they are hard."

—John F. Kennedy, 1961

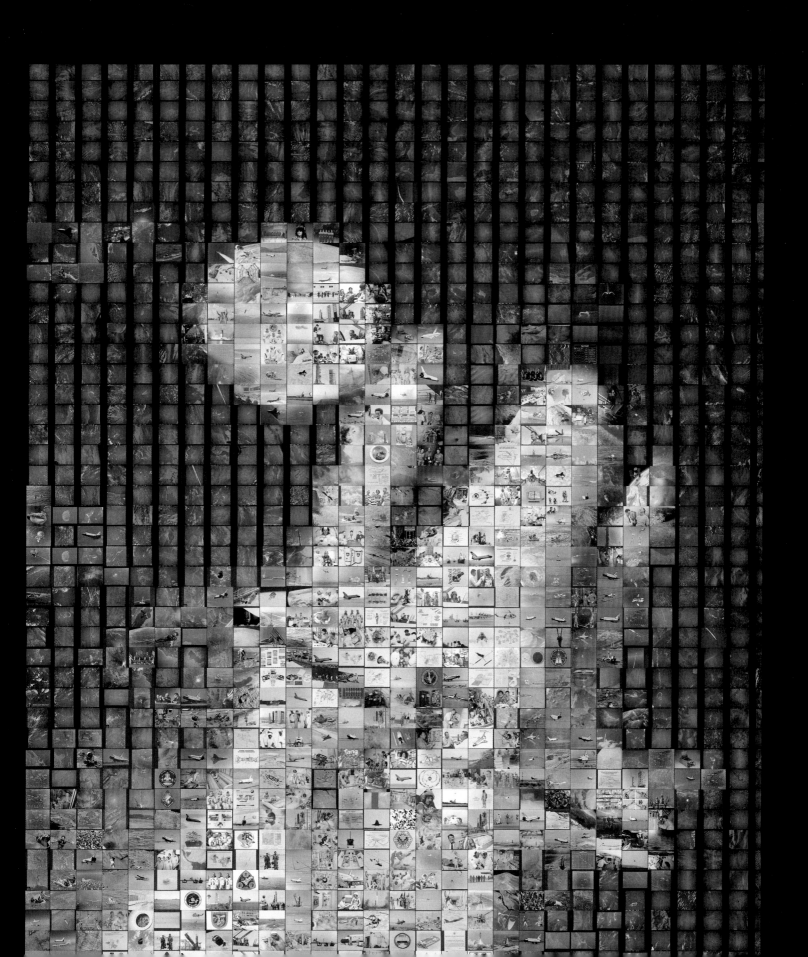

Darth Vader

"Don't be too proud of this technological terror you've constructed. The ability to destroy a planet is insignificant next to the power of the Force."

—Darth Vader
in *Star Wars*

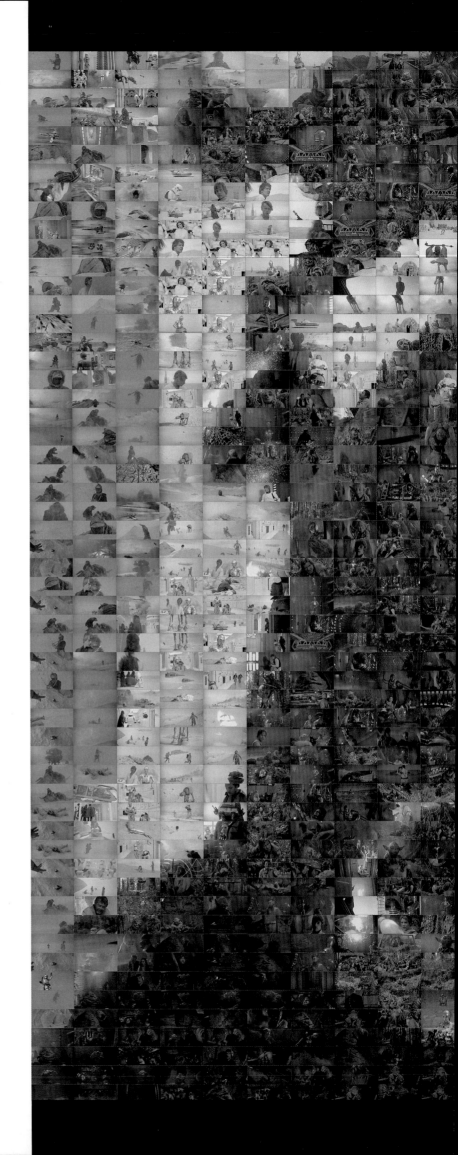

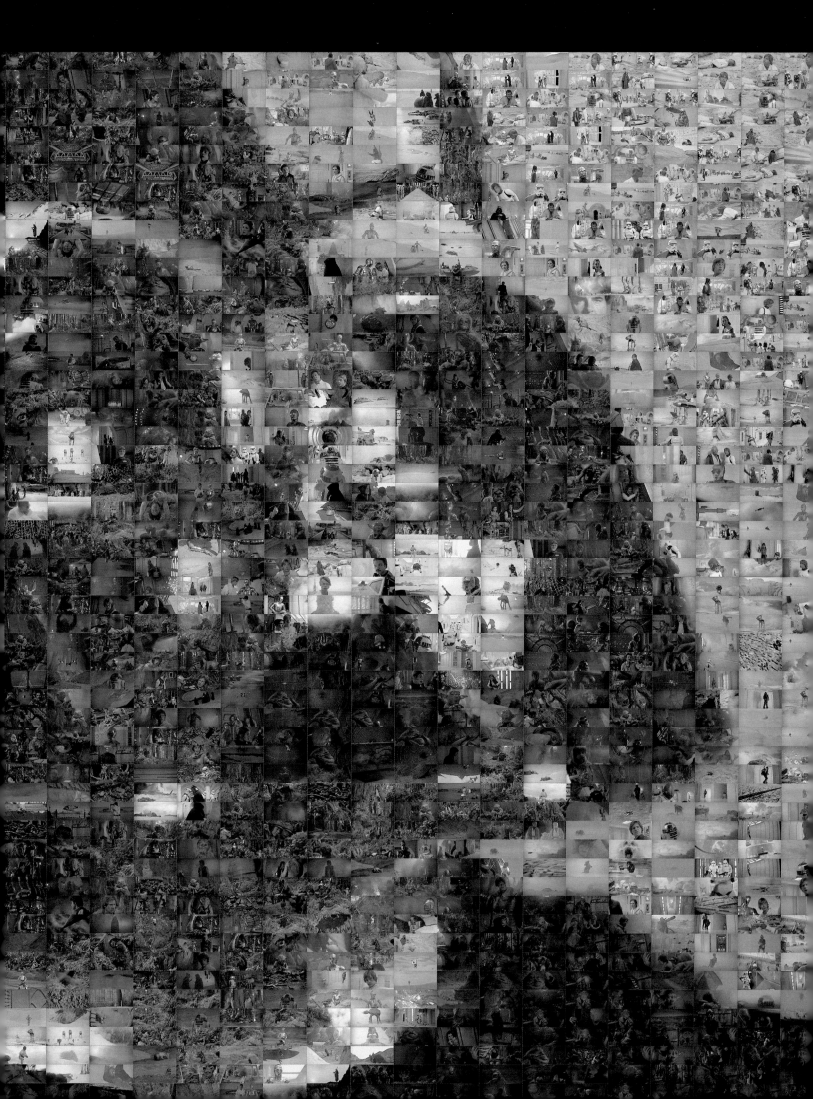

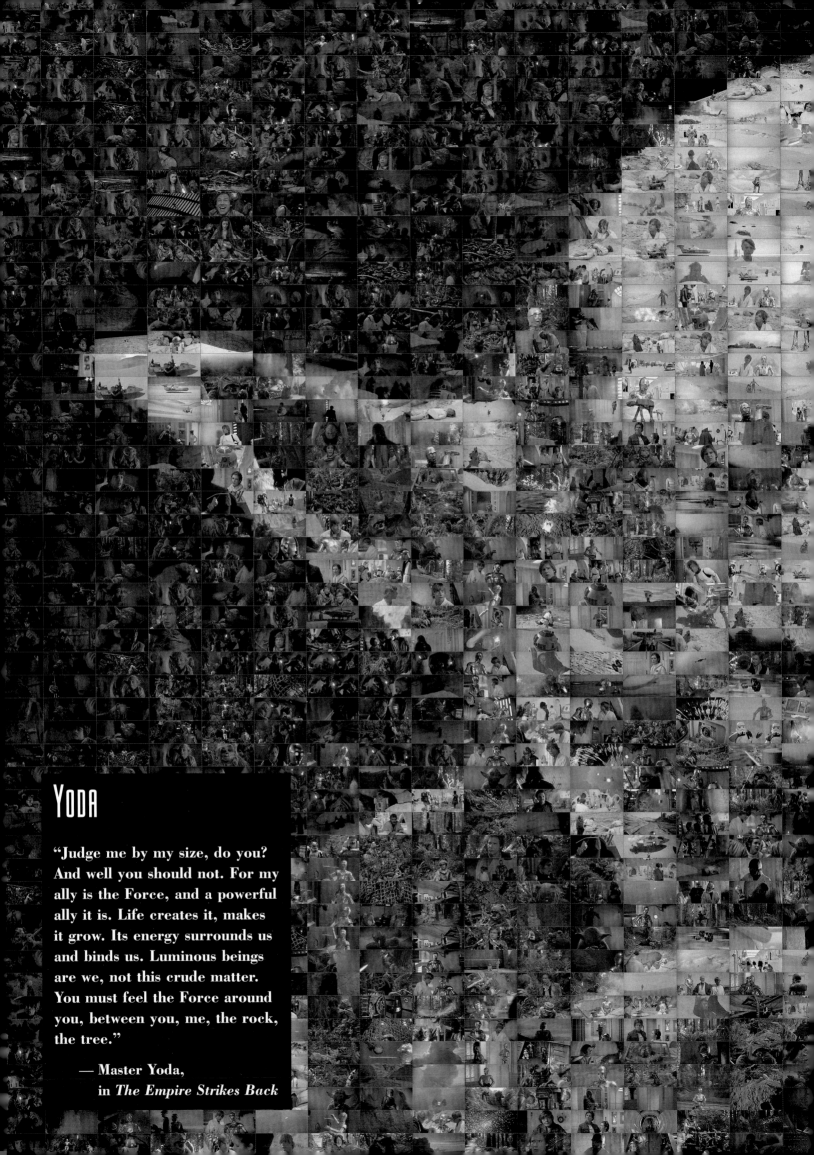

YODA

"Judge me by my size, do you? And well you should not. For my ally is the Force, and a powerful ally it is. Life creates it, makes it grow. Its energy surrounds us and binds us. Luminous beings are we, not this crude matter. You must feel the Force around you, between you, me, the rock, the tree."

— Master Yoda,
 in *The Empire Strikes Back*

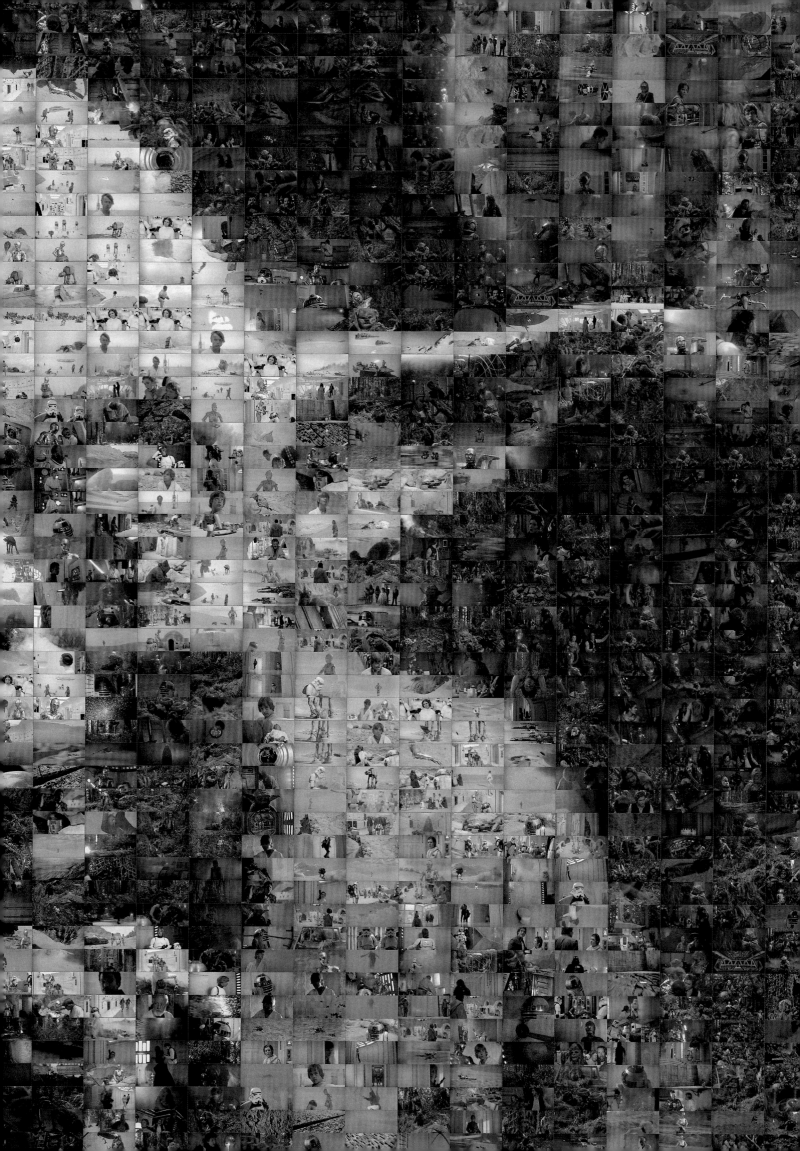

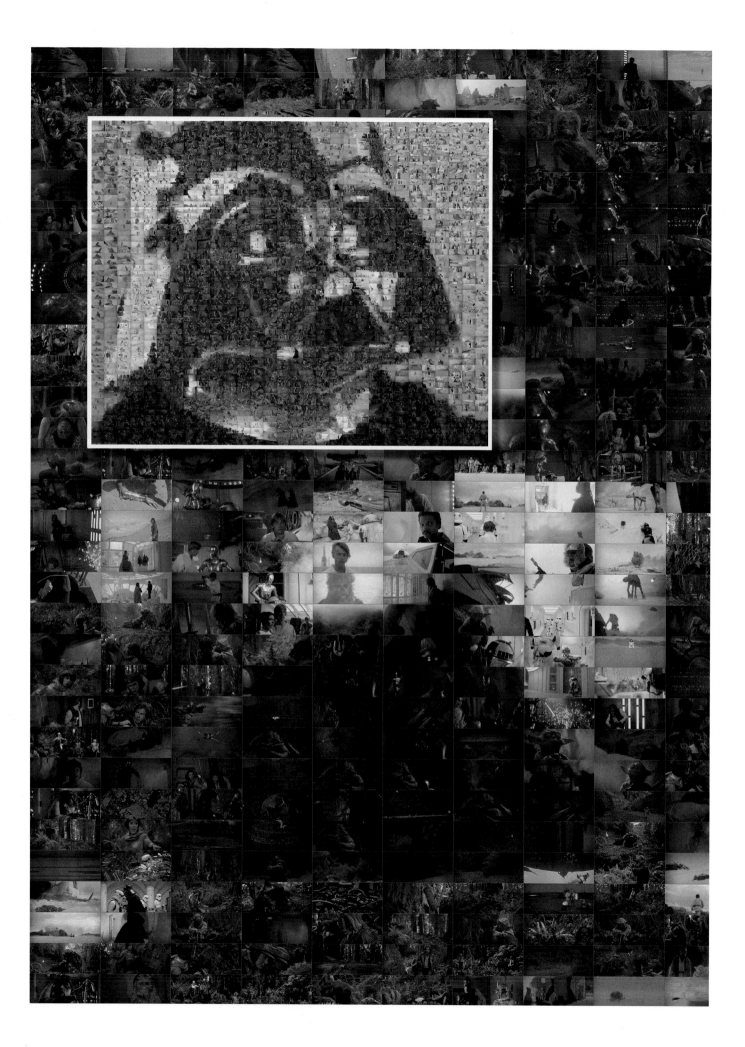

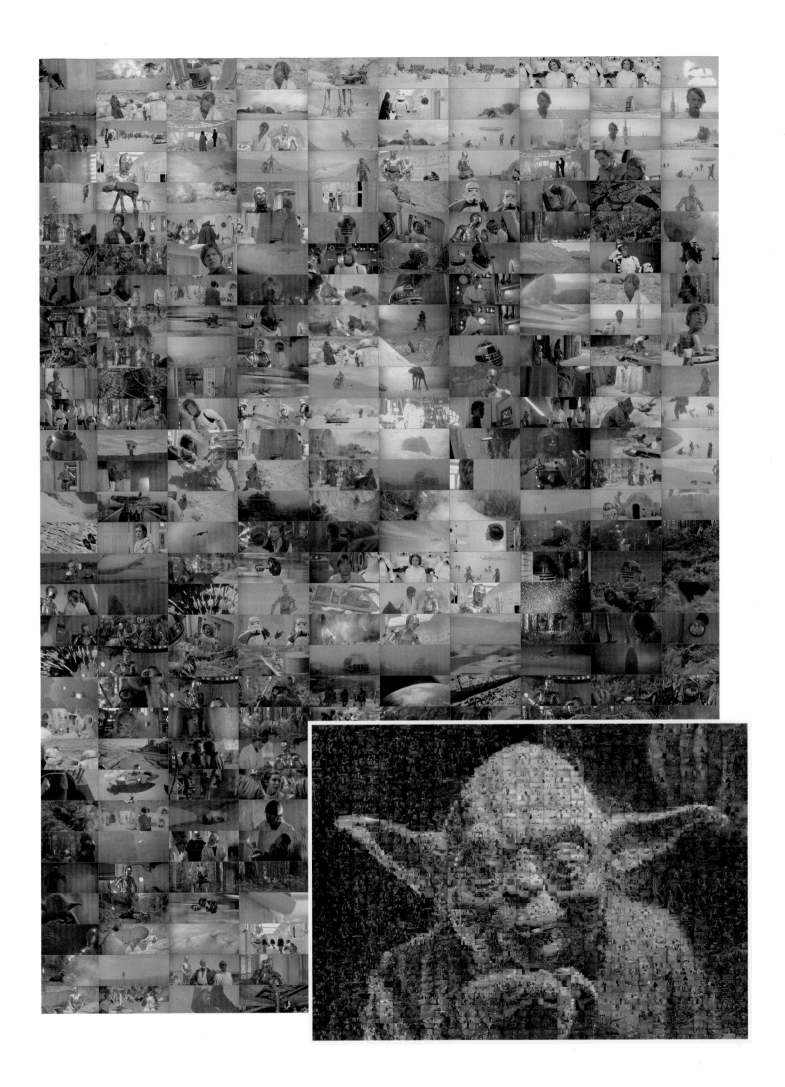

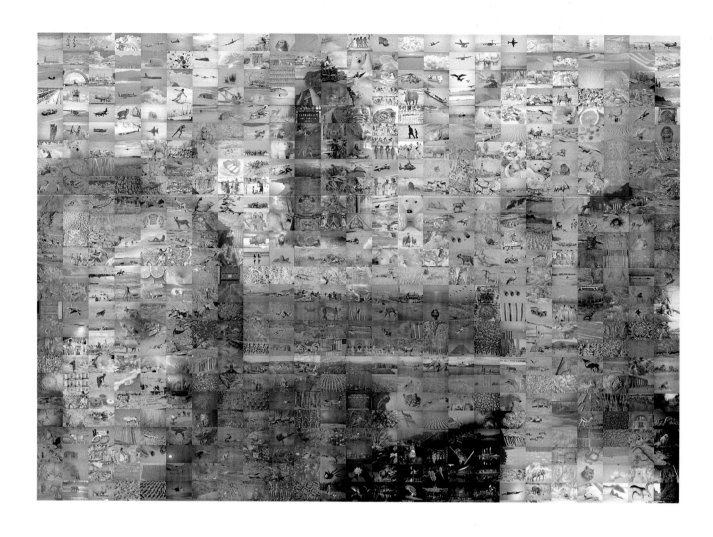

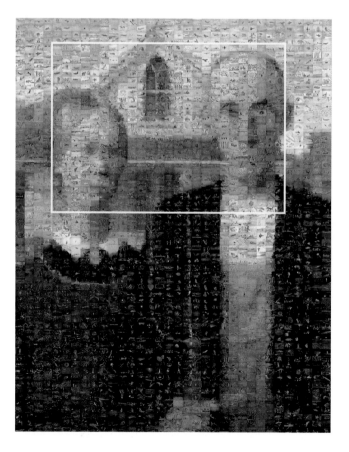

AMERICAN GOTHIC

The Iowa painter Grant Wood (1892–1942) was an exponent of "American regionalism," but he is remembered above all for *American Gothic.* When the painting won a bronze medal in a 1920 Chicago exhibition, it was immediately seen as a mockery of country folk. But critics loved it, and in the surrounding furor, an American icon was born.

Sources of Wood's painting can be seen in the tiled images, many of which are of farms and farming. But also at play was his recent experience in Munich, where he had overseen the fabrication of a stained-glass window designed for the Veterans Memorial in Cedar Rapids. While in Germany, he greatly admired works by Dürer, Holbein, and especially Memling, and their influence, just as much as the faces and scenes from his childhood, can be seen in the painting.

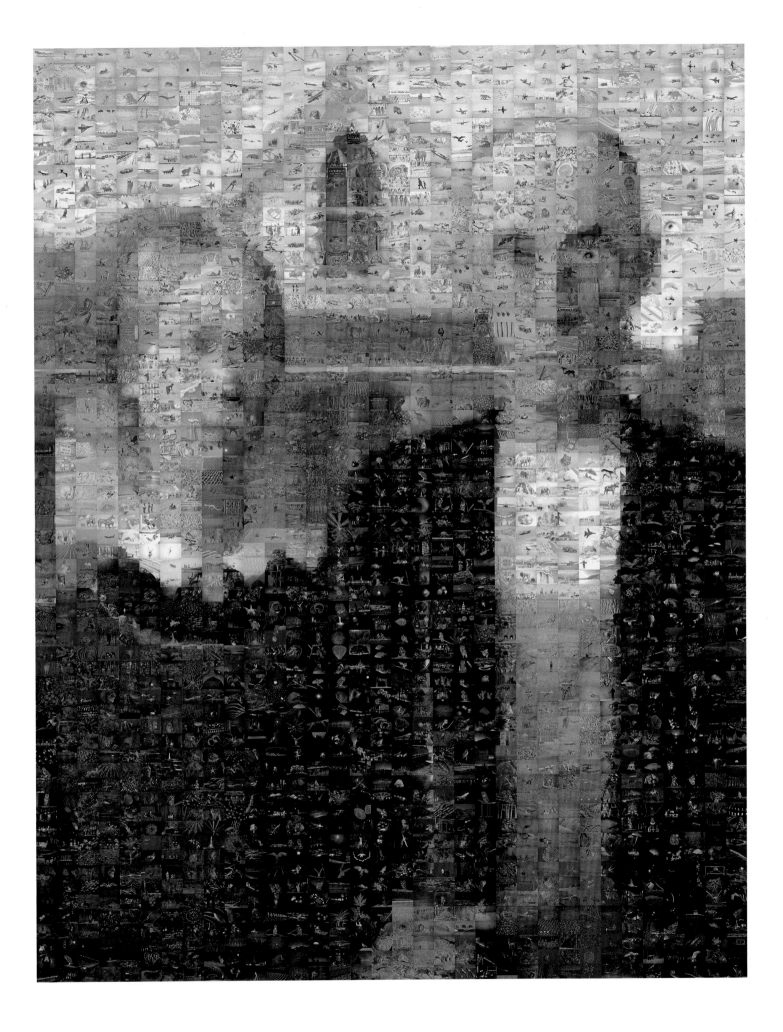

Dollar Bill

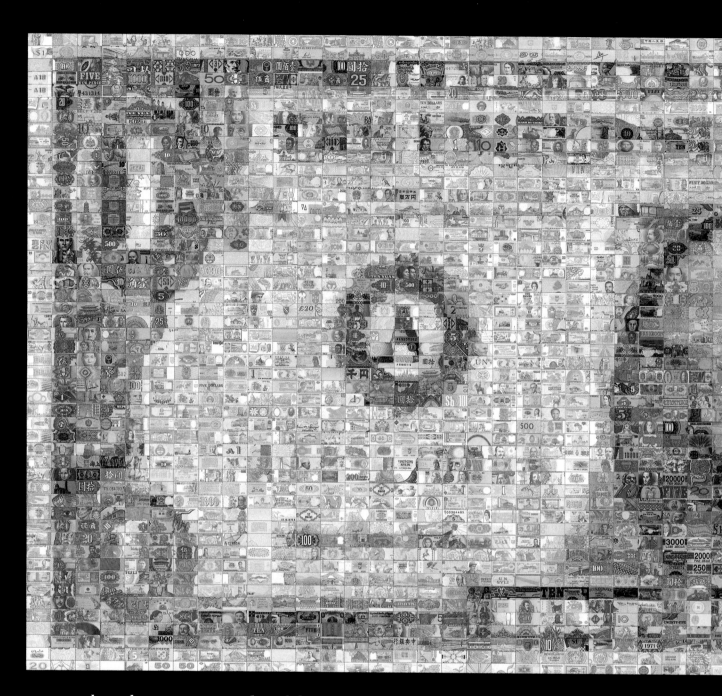

novus ordo seclorum—a new order of the ages

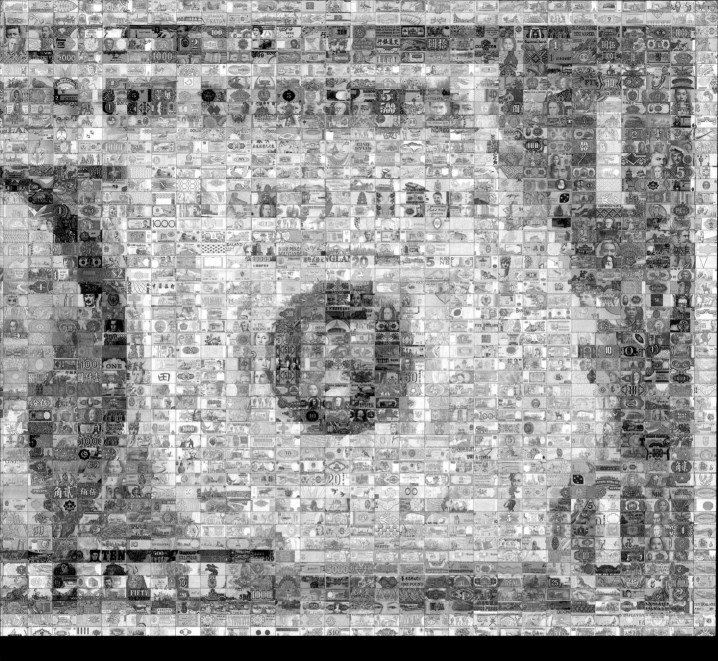

All that glitters is not gold, nor does all that is gold glitter. When Marco Polo visited China, he was astonished to discover paper money. Today what's astonishing is not just the interchangeability of currencies worldwide but the huge thriving and growing commerce based not on coin, and not on paper, but on electronic bits.

In this and the next two images, the U.S. dollar is tiled together from other coins of the realm: first, from more than 1,500 images of currency from around the world, then from credit cards.

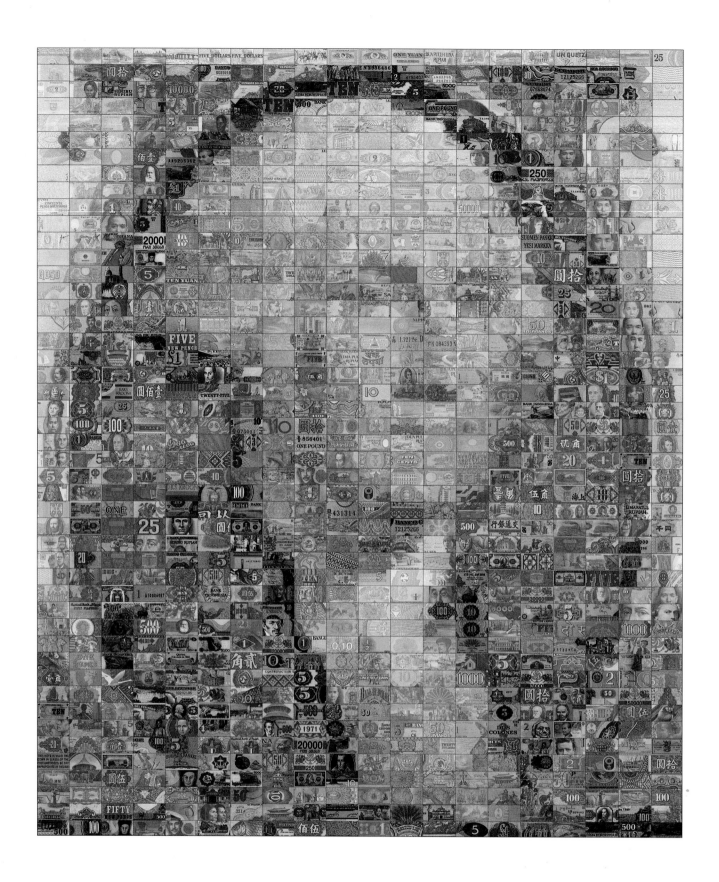

GEORGE WASHINGTON

BEFORE (ANALOG)

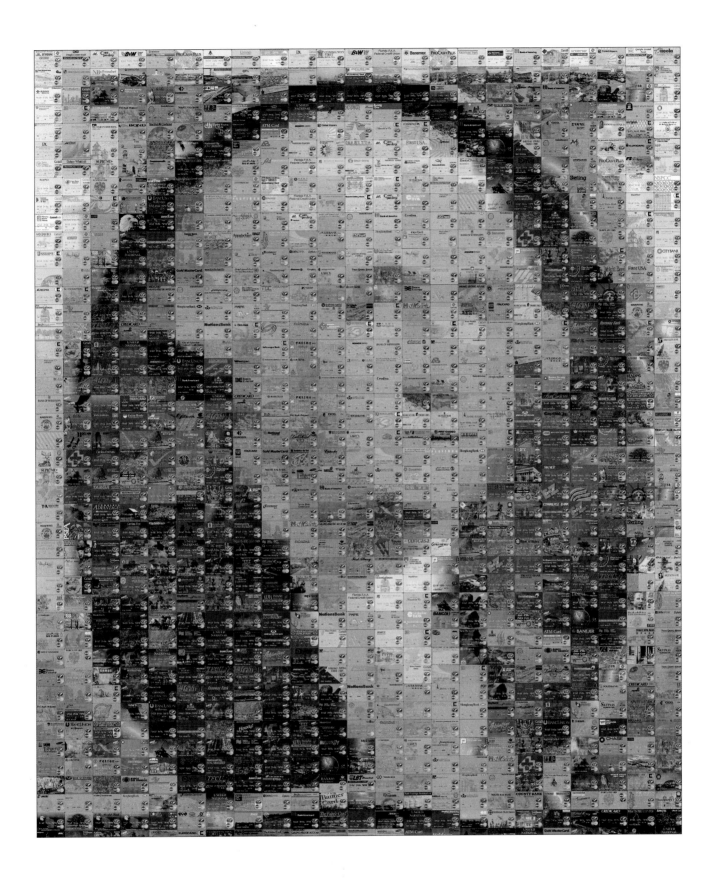

George Washington

AFTER (DIGITAL)

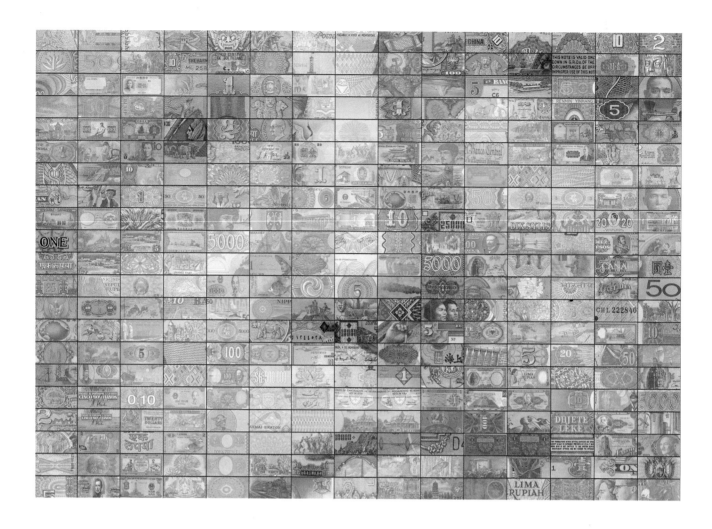

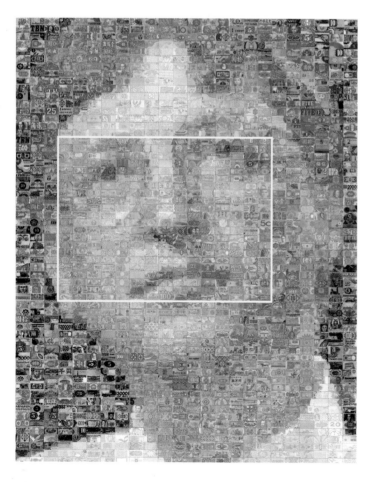

Bill Gates

When asked in 1986 if he ever wished to go back to programming, Gates responded:

"Oh, sure, absolutely. Then you control everything. There's no compromise. Every line is yours and you feel good about every line. It's kind of selfish, but it's like being allowed to do pure mathematics, and yet you have the feedback of making something really work. I sometimes envy my colleagues who get to focus just on the program they're writing."

—William Gates,
in *Programmers at Work*,
by Susan Lammers

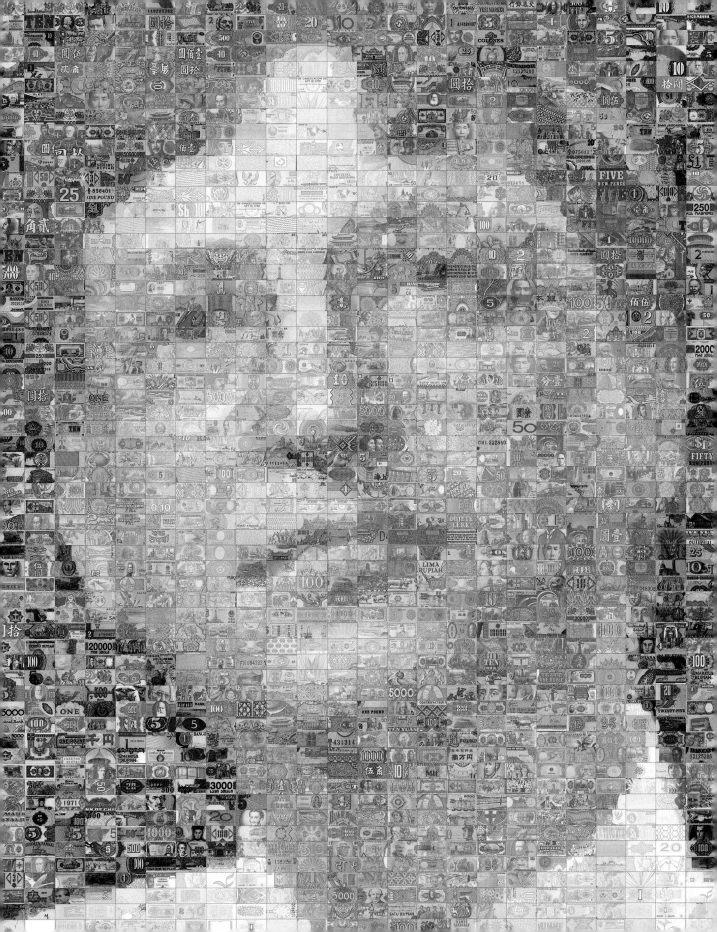

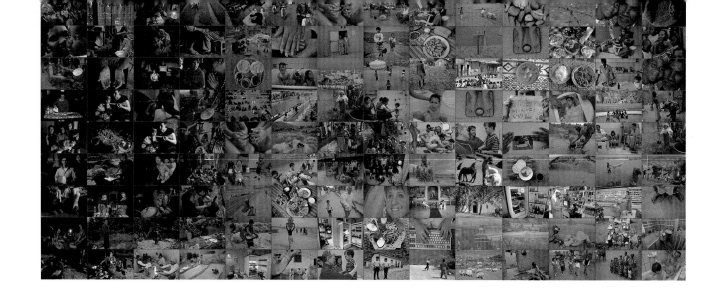

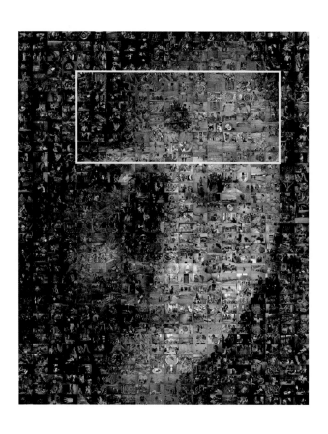

MISHRI

Only twenty-five years old, Mishri Yadav of Uttar Pradesh, India, is a mother of five who resides in a simple house she built by hand with her husband, Bachau. Mishri was betrothed at age ten to her husband, whom she had never met, and married him at age fifteen. She is illiterate, as are 66 percent of women in India, but both her sons and daughters attend the village school. She is happy about this, she says, but she wants her oldest daughter, Sunita, to marry as she did—at an early age. Mishri's photomosaic portrait is composed of more than seven hundred images from the work of the ten photographers who contributed to the Material World Women's Project and the sixteen photographers who contributed to *Material World.*

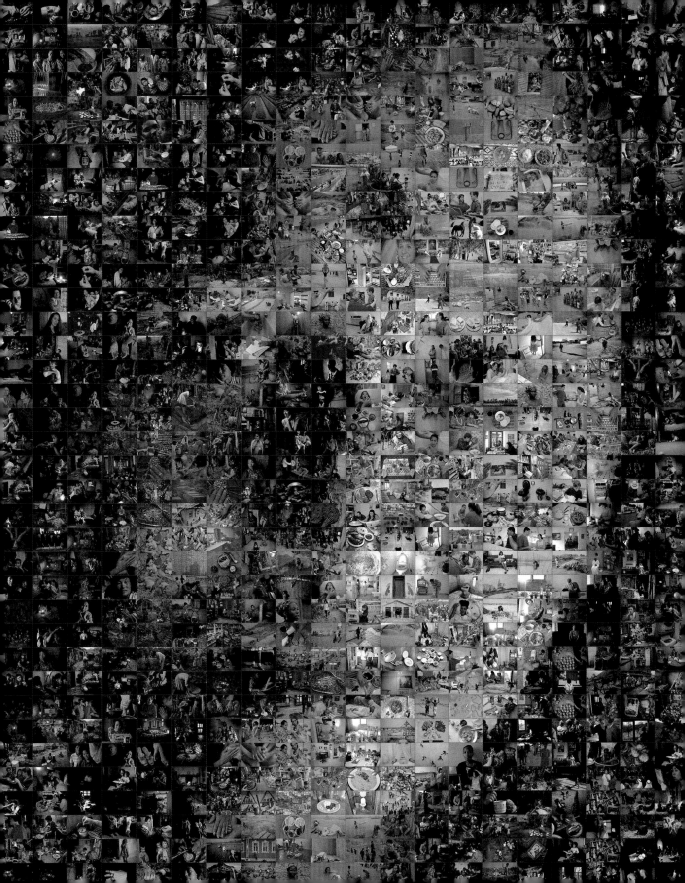

MATERIAL GIRL

It wasn't photographing the oil-well fires in Kuwait or the anarchy of war-torn Somalia that pushed me over the edge. It was hearing a National Public Radio story in late 1992 about the marketing of pop singer Madonna's sex-fantasy book. The radio report ended with the pop star's song "Material Girl," which triggered my desire to find out if average people could be as interesting as those who are decidedly not average. I set out to photograph the daily lives of thirty average families around the world.

We made portraits of each family outside their home, surrounded by all of their material possessions. The resulting book, *Material World: A Global Family Portrait,* became a best-seller, and proved that the lives of average people can indeed be just as interesting as those of extreme celebrities. The images in this photomosaic are of daily life around the world from the work of sixteen photographers shooting for *Material World* and ten photographers shooting for the Material World Women's Project.

—Peter J. Menzel,
Napa, California
January 1997

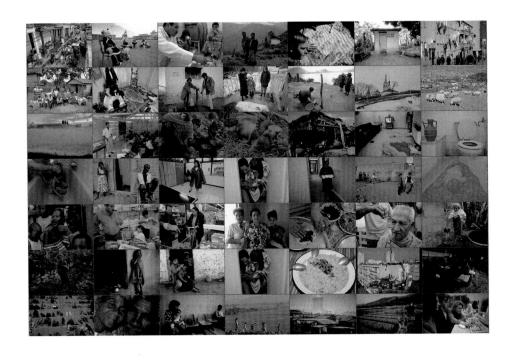

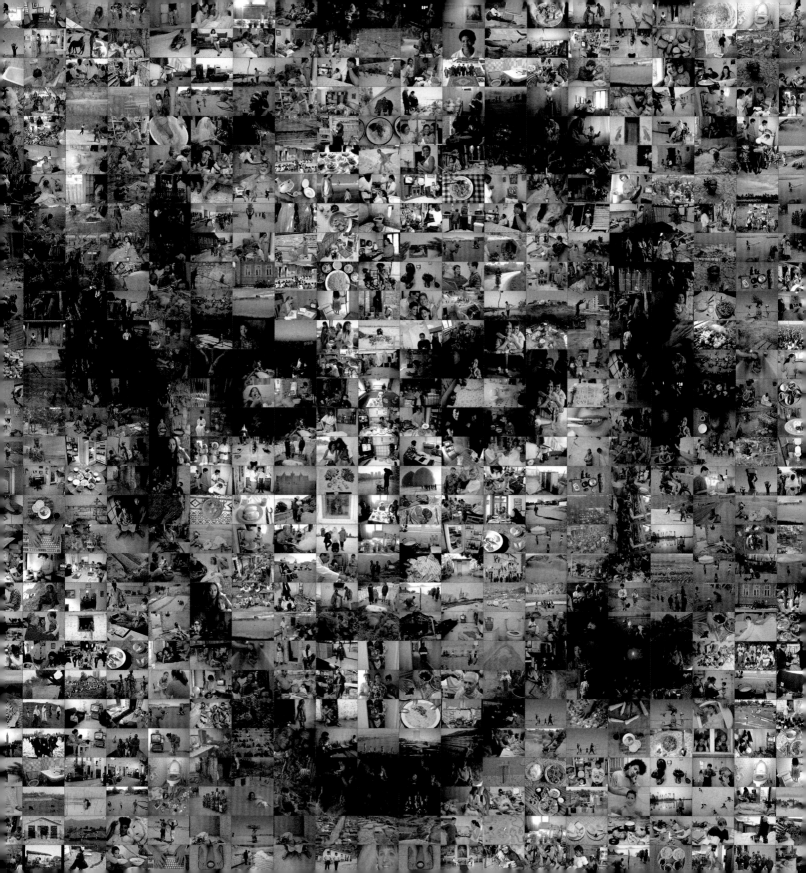

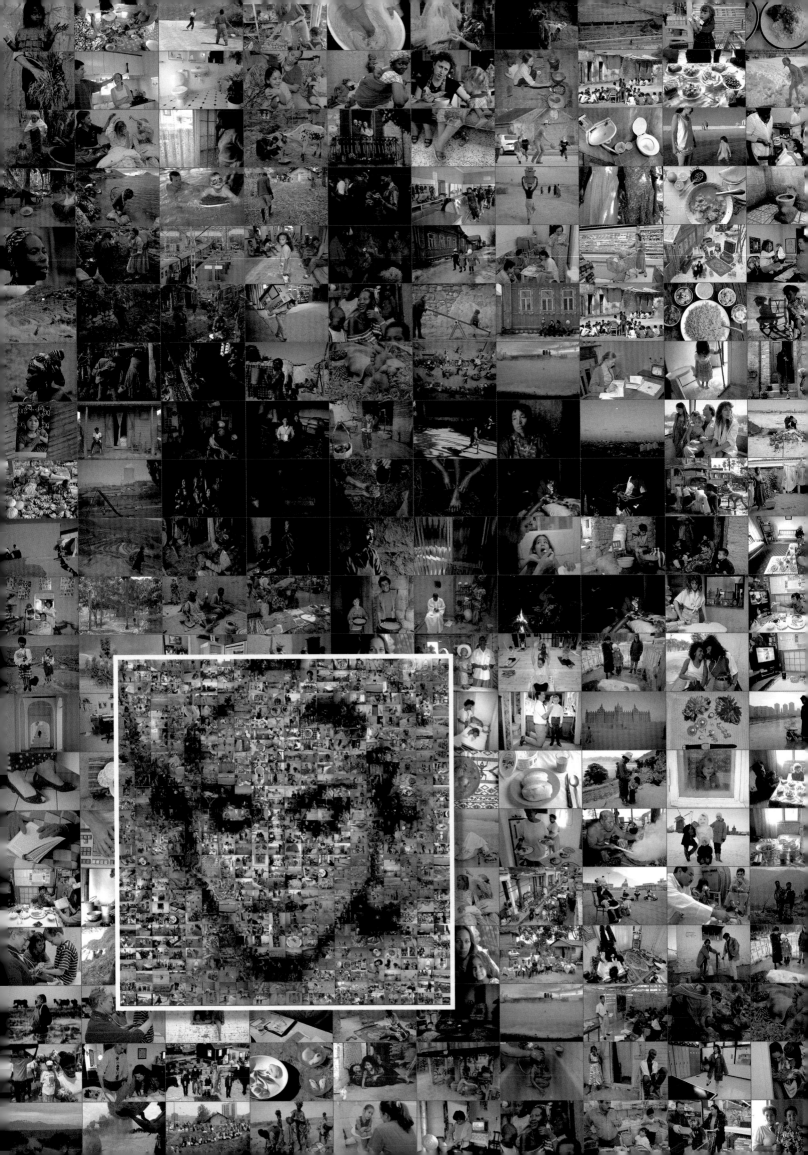

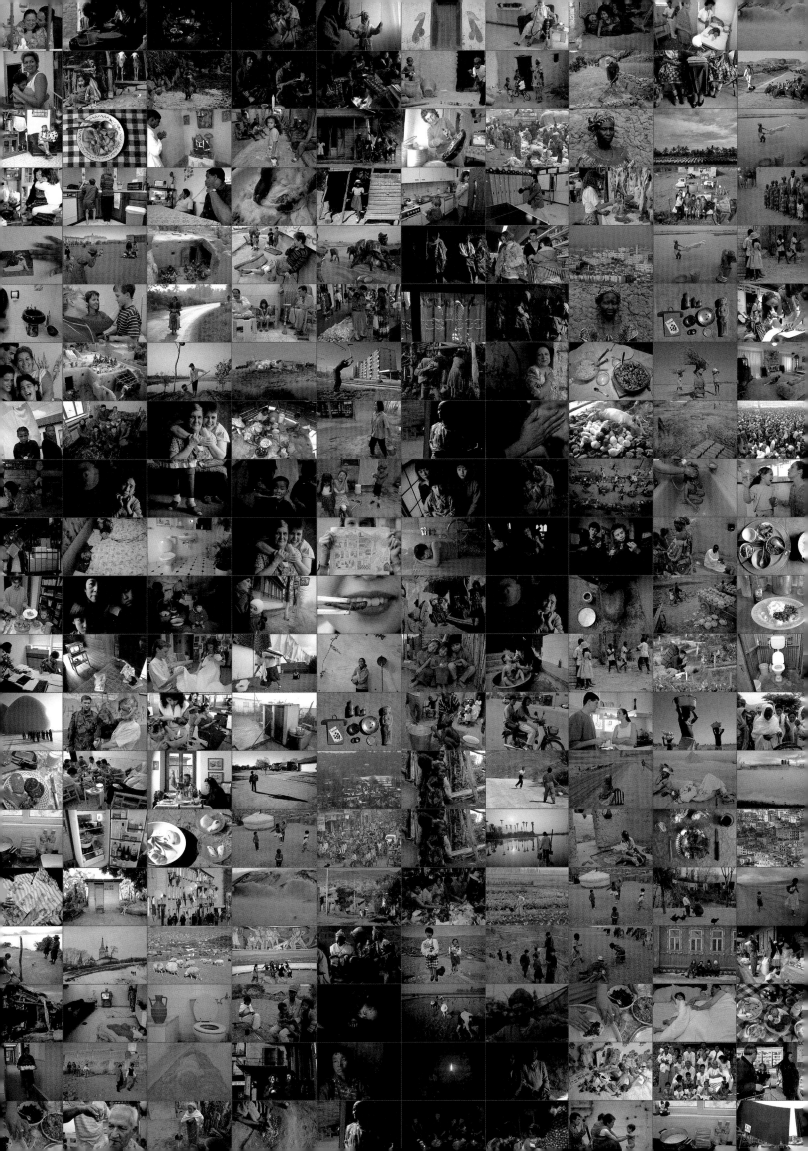

The Flower Carrier

The painter Diego María Concepción Juan Nepomuceno Estanislao de la Rivera y Barrientos Acost y Rodríguez—known to the world as Diego Rivera—was born in 1886 in Mexico. He studied in Spain and settled in Paris, where along with Braque and Picasso he was drawn to Cubism before moving on to a post-impressionistic style marked by simple shapes and bold colors. He returned to Mexico in the 1920s and painted scenes of agricultural and industrial life.

In its original form *The Flower Carrier* looks almost like a jigsaw puzzle, with people put together from circles, cylinders, and triangles. In our photomosaic, the painting is constructed of images of flowers, and flowers, and flowers . . . and, if you look carefully, an antique seed catalog.

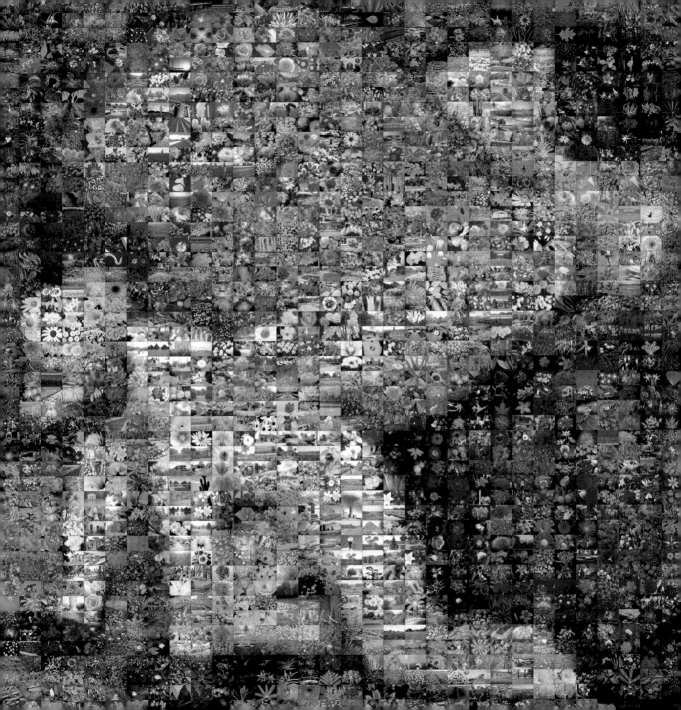

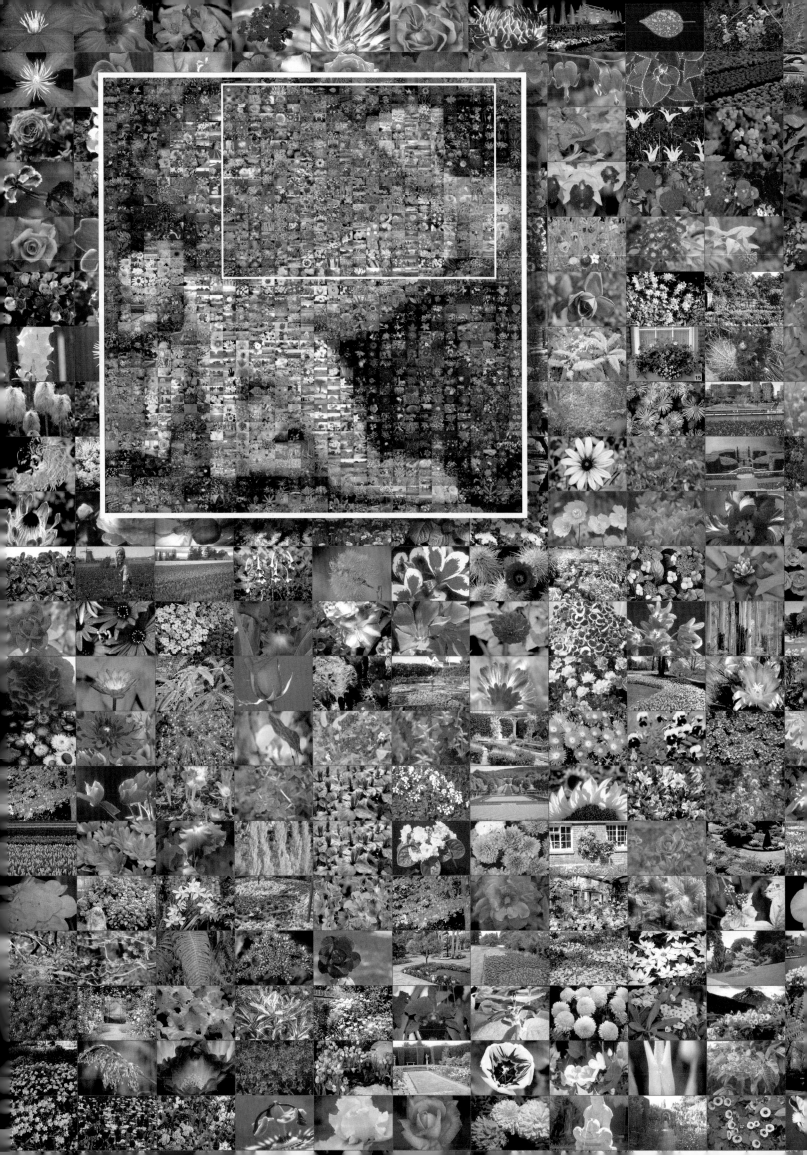

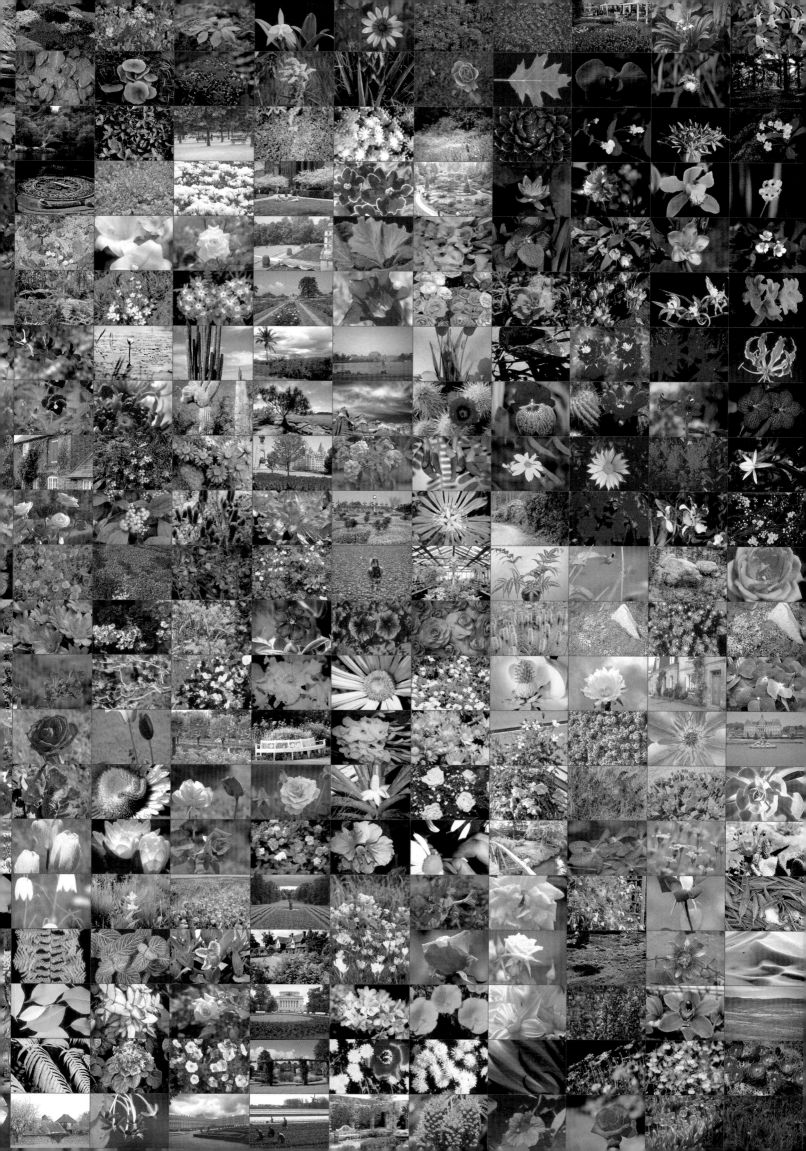

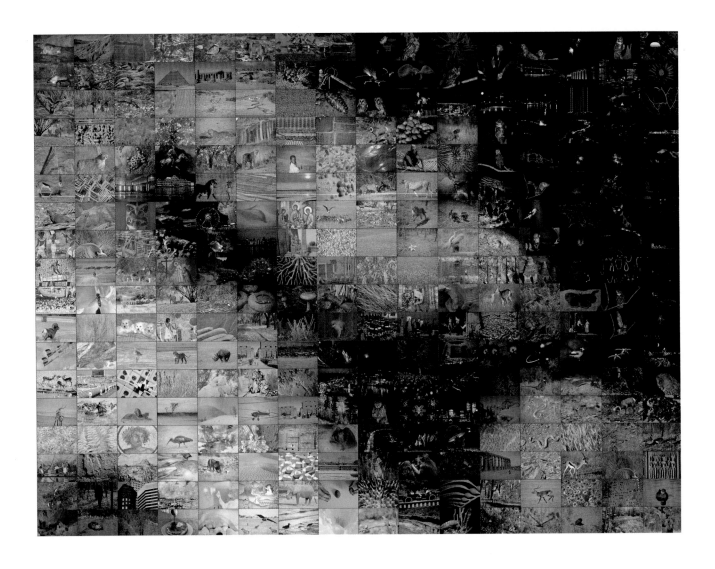

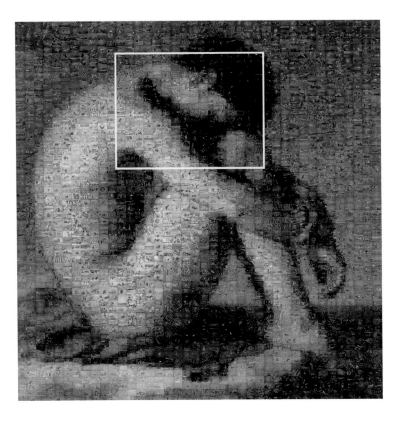

Jeune Homme Nu

Young Man by the Sea, by Hippolyte Flandrin (1809–1864). Sent back to Paris from Rome by the young painter, this study of a sensuous and solitary boy became and has remained one of Flandrin's most beloved paintings.

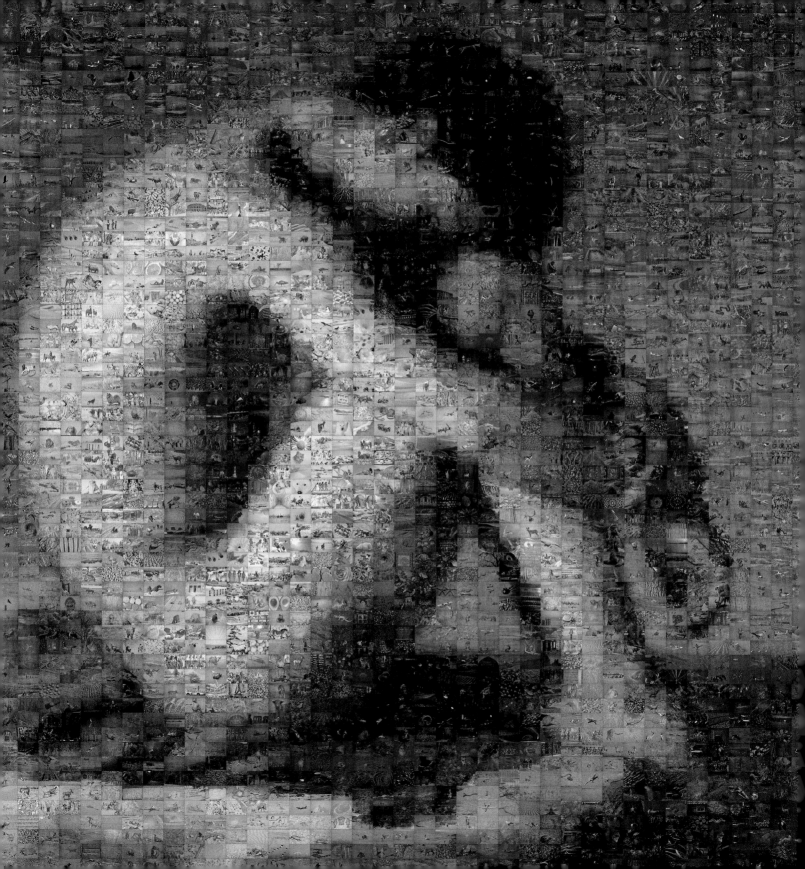

Mona Lisa

"When you look at a wall spotted with stains, or with a mixture of stones, if you have to devise some scene, you may discover a resemblance to various landscapes, beautiful with mountains, rivers, rocks, trees, plains, wide valleys and hills in varied arrangements; or again you may see battles and figures in action; or strange faces and costumes, and an endless variety of objects, which you could reduce to complete and well-drawn forms. They appear on such walls confusedly, like the sound of bells in whose jangle you may find any name or word you choose to imagine."

—Leonardo da Vinci (1452–1519)

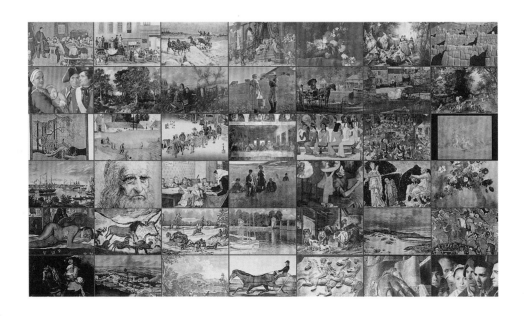

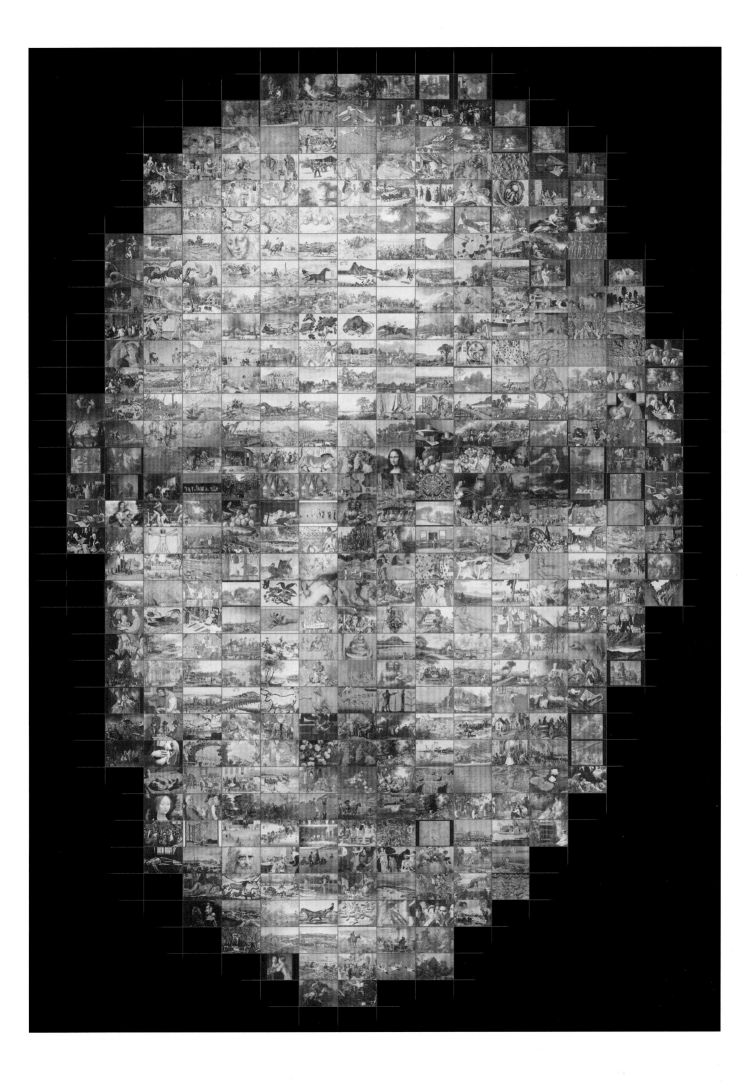

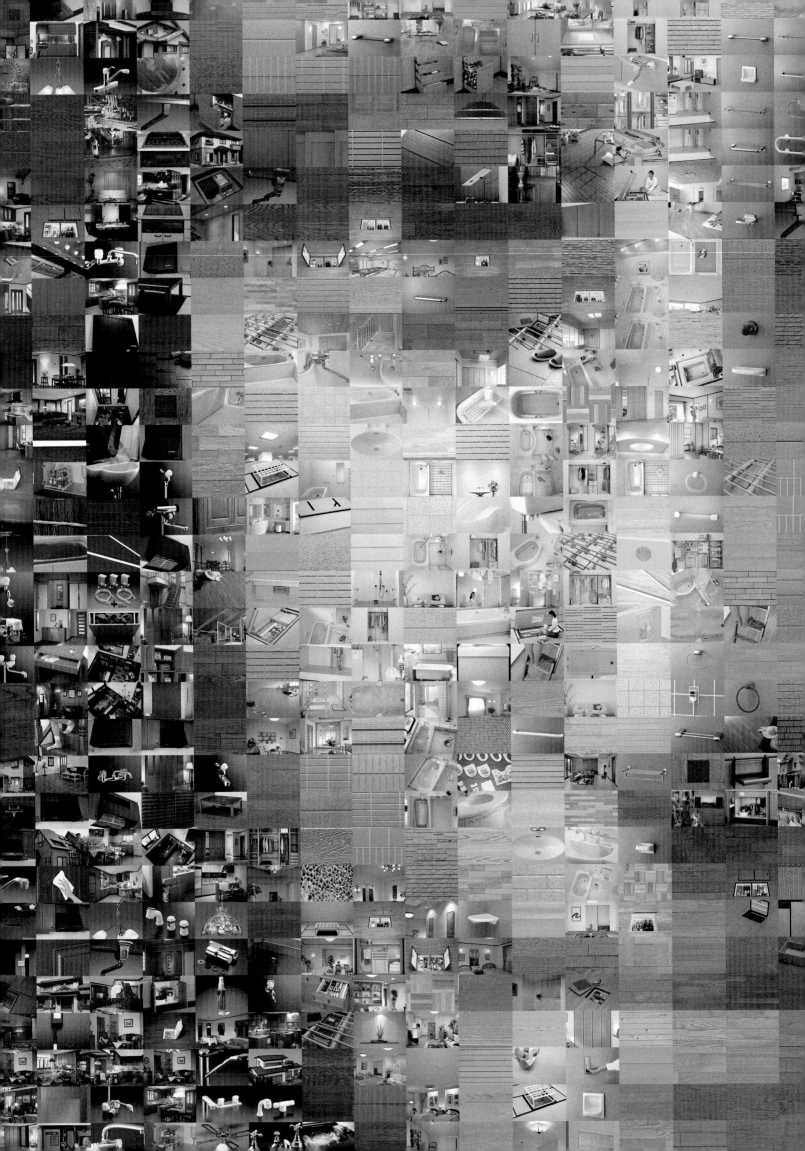

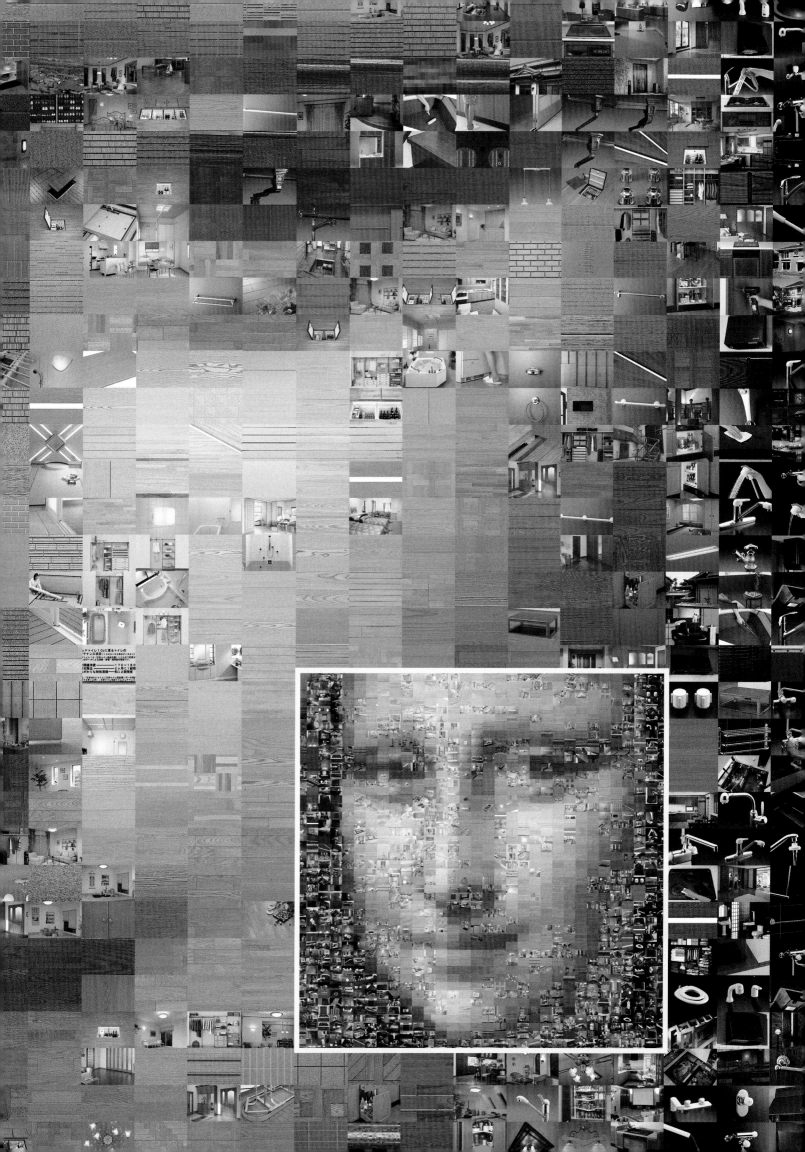

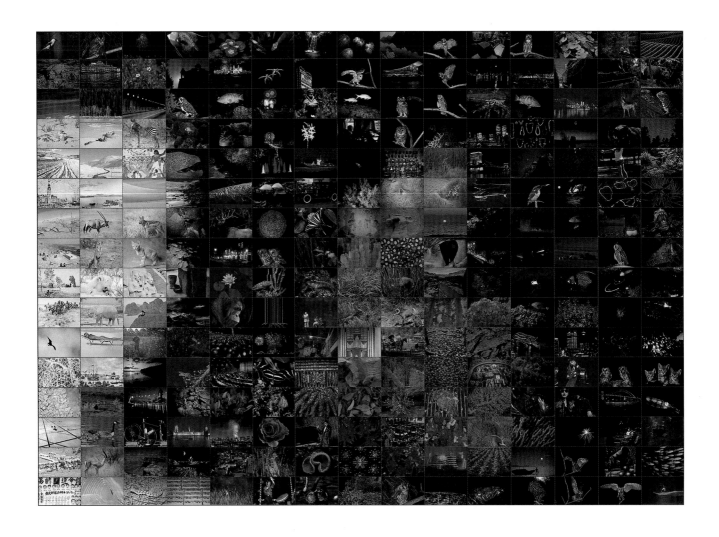

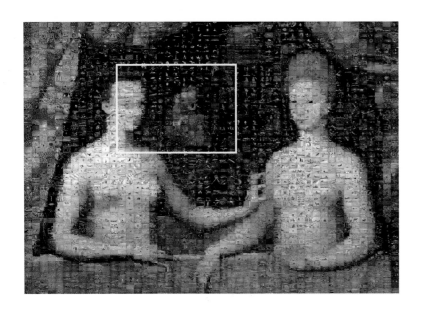

L'ECOLE DU FONTAINEBLEAU

Gabrielle d'Estrées et une de ses soeurs
(c. 1595), from the second school of
Fontainebleau.

 This mysterious portrait of a pair
of young women in a bath is thought
to show two sisters. Gabrielle, on the
right, was mistress to King Henry IV
of France; she holds a ring—perhaps
signifying his devotion to her. Her
sister, holding her nipple, may signify
Gabrielle's impending motherhood:
she bore Henry three children.

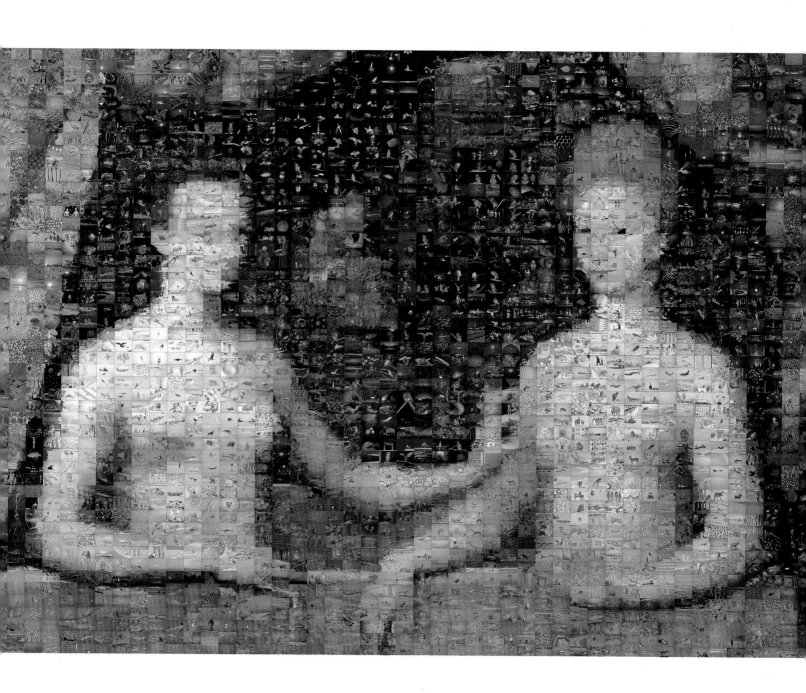

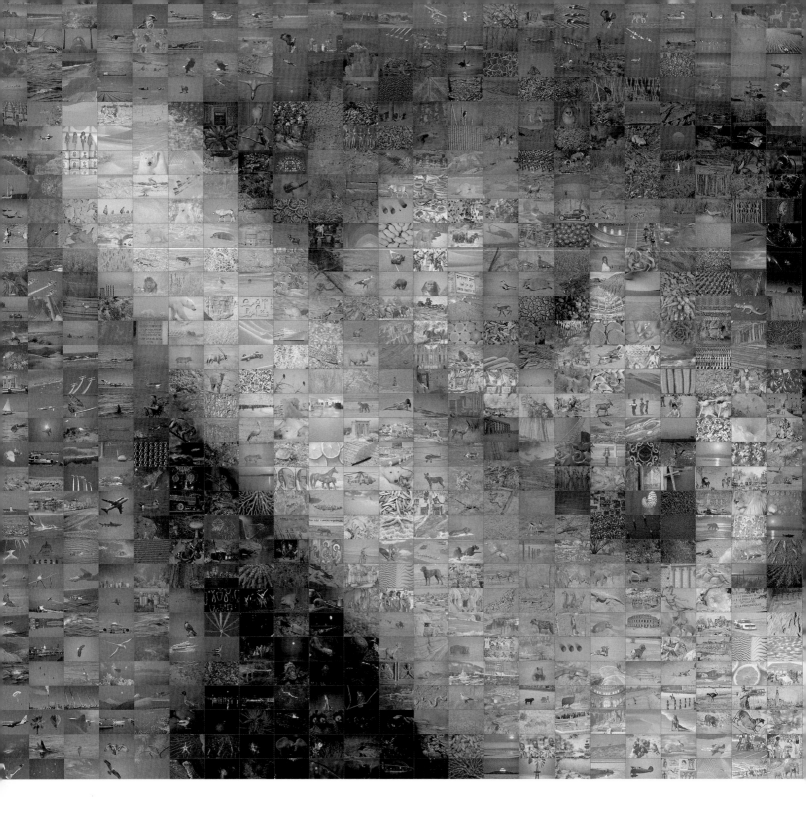

Marilyn / Nude

"Her life has become an American myth. Her rise to stardom and her tragic death are chronicled in numerous books, and it would seem that every known photograph of her has been unearthed and published."

—André de Dienes,
Marilyn, Mon Amour

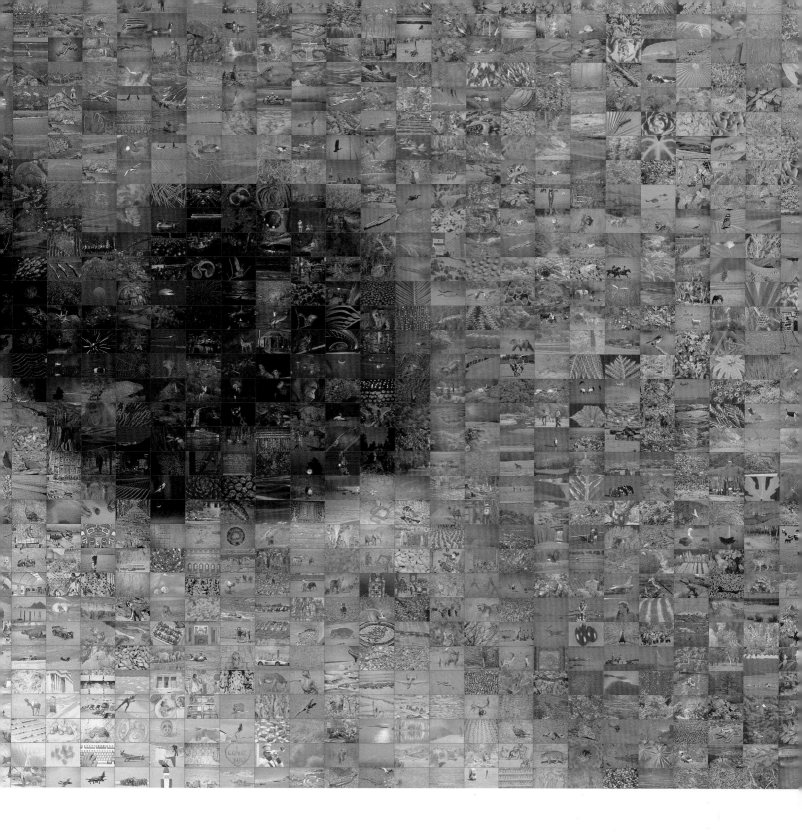
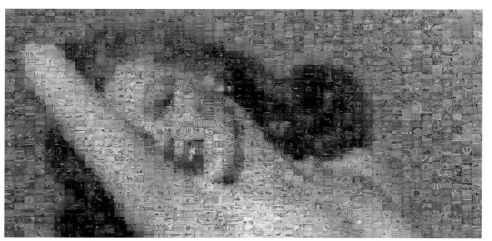

La Grande Jatte

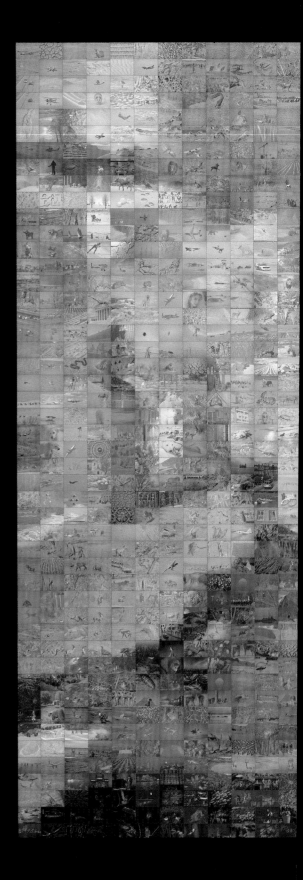

"Under a blazing midafternoon summer sky, we see the Seine flooded with sunshine, smart town houses on the opposite bank, and small steamboats, sailboats, and a skiff moving up and down the river. Under the trees closer to us, many people are strolling, others are sitting or stretched out lazily on the bluish grass. A few are fishing. There are young ladies, a nursemaid, a Dantesque old grandmother under a parasol, a sprawled-out boatman smoking his pipe, the lower part of his trousers completely devoured by the implacable sunlight. A dark-colored dog of no particular breed is sniffing around, a rust-colored butterfly hovers in mid-air, a young mother is strolling with her little girl dressed in white with a salmon-colored sash, two budding young Army officers from Saint-Cyr are walking by the water. Of the young ladies, one of them is making a bouquet, another is a girl with red hair in a blue dress. We see a married couple carrying a baby, and, at the extreme right, appears a scandalously hieratic-looking couple, a young dandy with a rather excessively elegant lady on his arm who has a yellow, purple, and ultramarine monkey on a leash."

"Given the phenomenon of the duration of the luminous impression on the retina, synthesis is logically the result."

"The means of expression is the optical mixture of tones, of tints (of local color and the illuminating color: sun, oil lamp, gas, etc.), that is, of the lights and of their reactions (shadows) following the laws of contrast, of gradation, of irradiation."

—Georges Seurat (1859–1891)

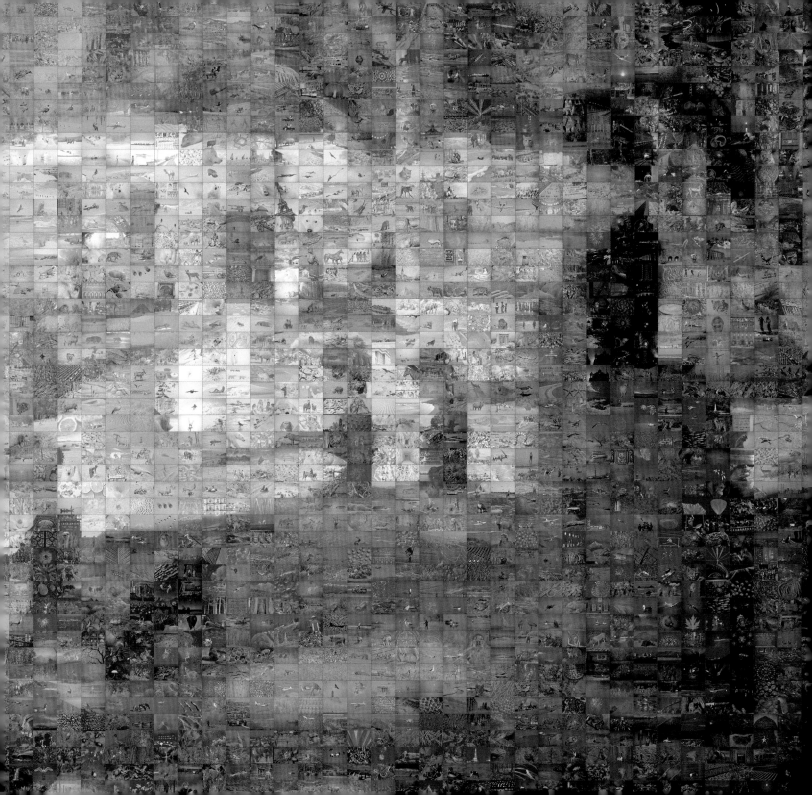

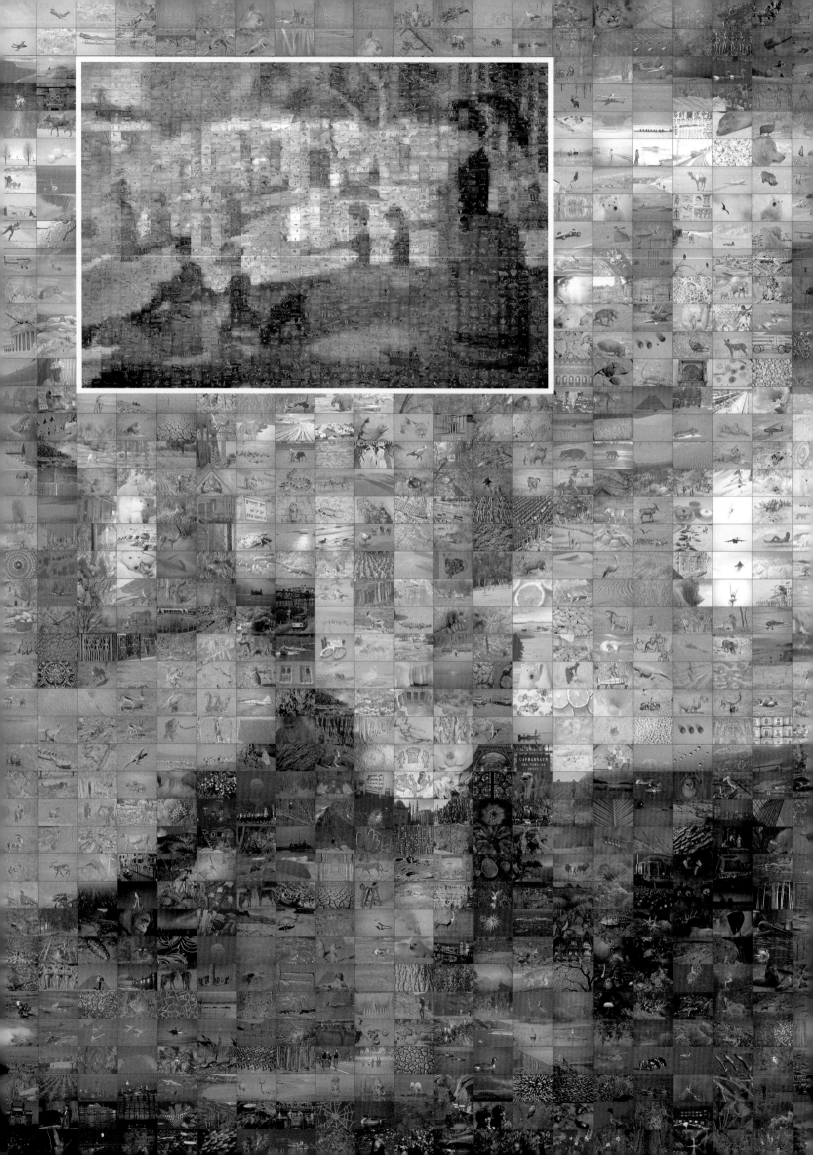

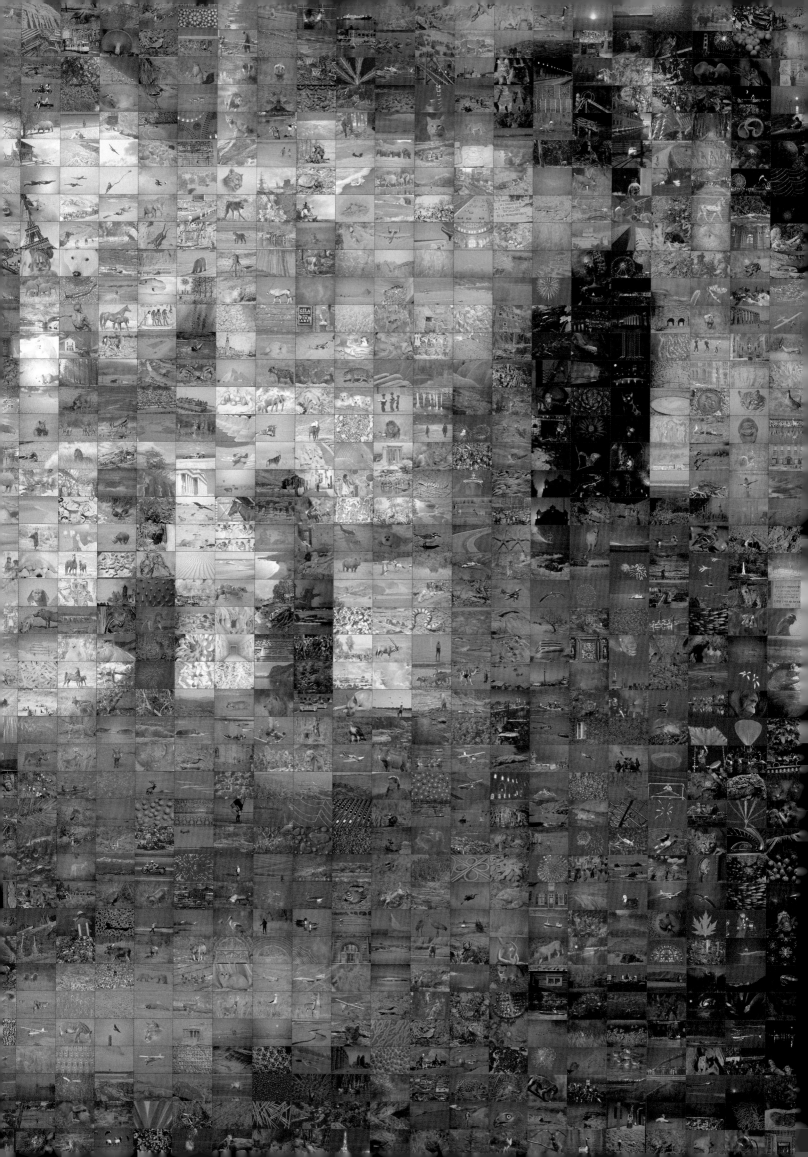

AIDS Memorial Quilt

Human face made from tiles of the
AIDS Memorial Quilt.

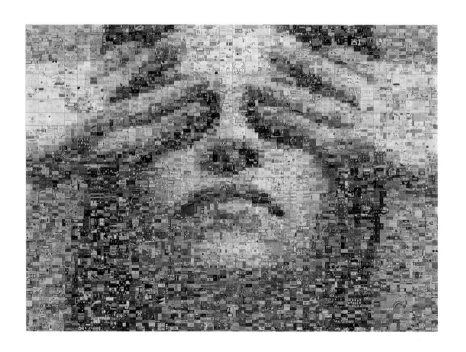

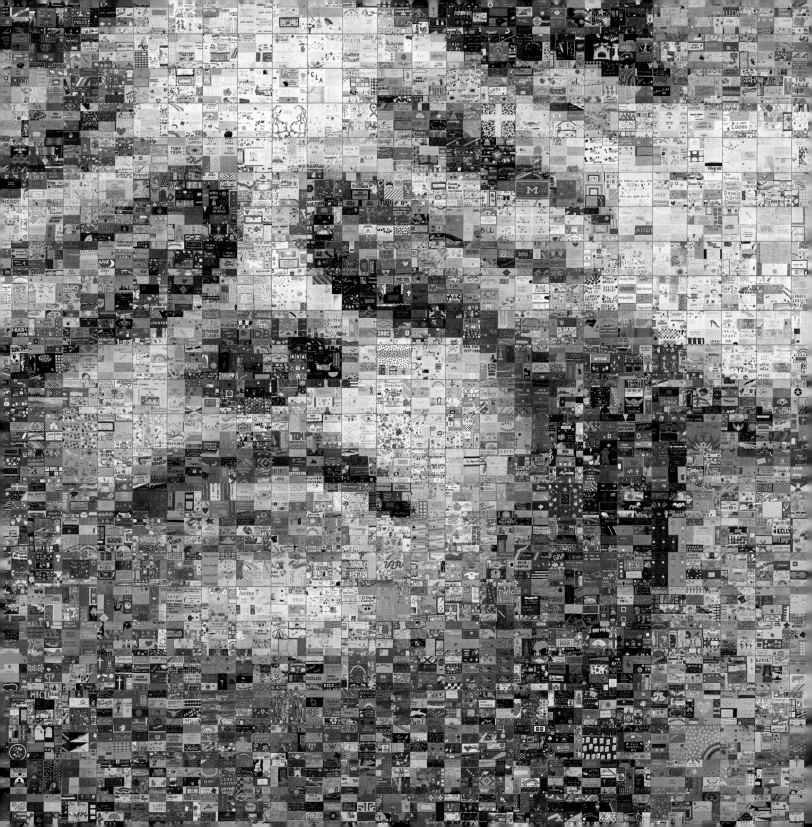

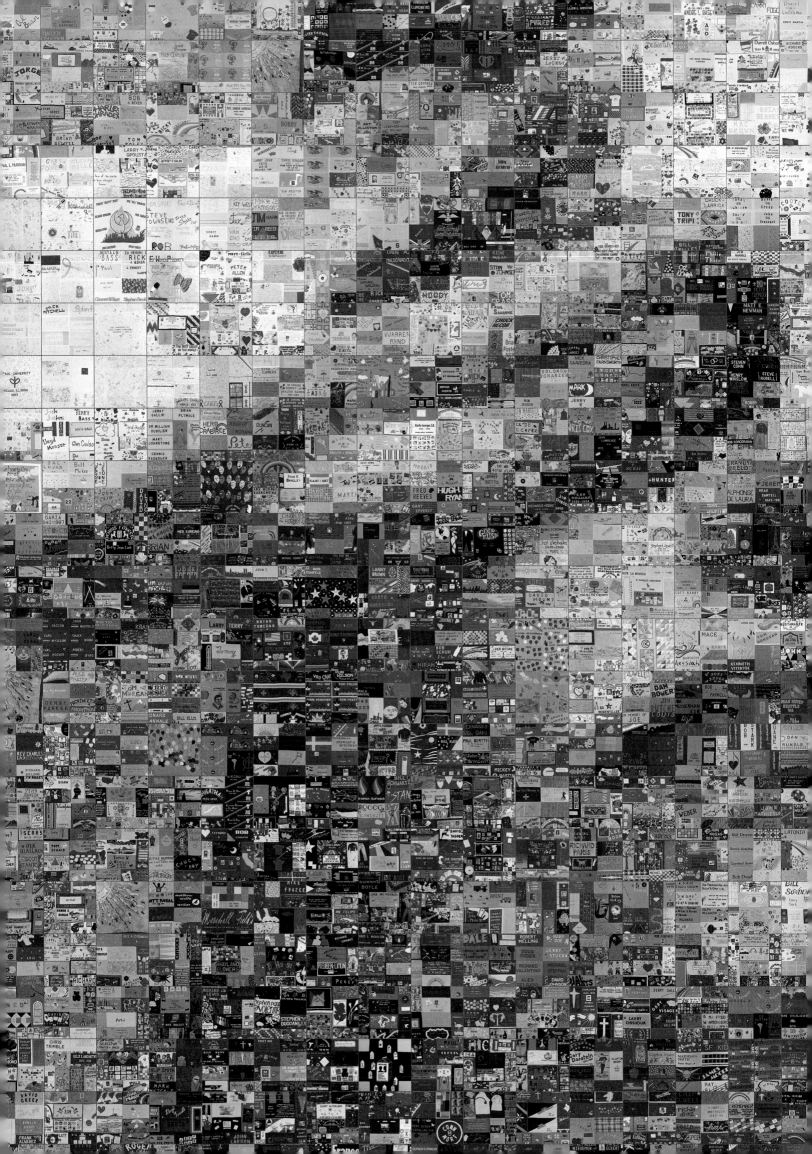

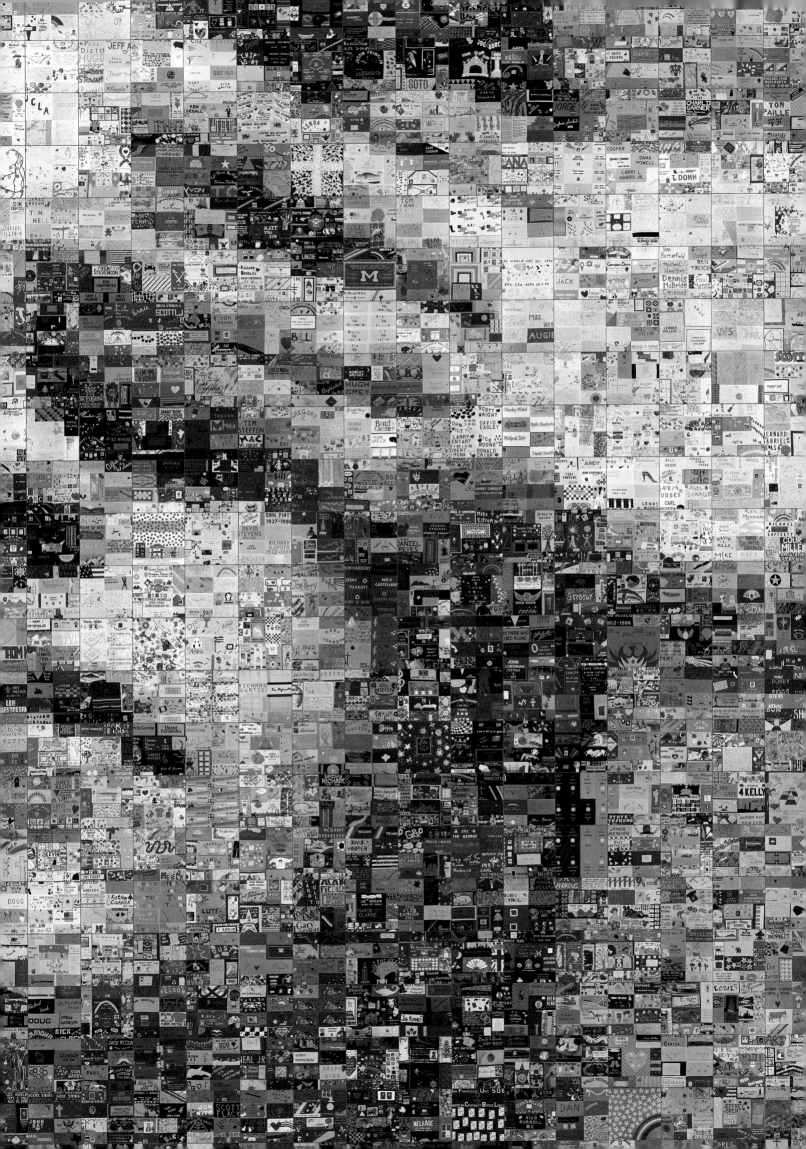

We thank many friends and colleagues who helped to make this work possible.

PEOPLE

Dan Adler, Walt Disney Company

Lucy Albanese, Henry Holt and Company

Lisa Alexander, Library of Congress

Kurt Andrews, Henry Holt and Company

John Athorn, Anderson & Lembke

Paul Bateman, MasterCard

Kris Becker, Ogilvy & Mather

Gary Bottger, Kodak

V. Michael Bove, Media Lab

Jeff Bridgers, Library of Congress

Alicia Brillon, PhotoDisc, Inc.

John Buford

Jeff Burak, The Stock Market

Woodfin Camp

Sergio Canetti, Nynex

Stephanie Chan, The Stock Market

Dave Chariton, William Morris Agency

Betsy Chimento, MIT

Nancy Clements, Henry Holt and Company

David Cohen

Pete Colangelo

Muriel Cooper, Media Lab

Heeday Danjo, Toppan

Faith d'Aluisio

Paul Farrell, Henry Holt and Company

Nathan Felde, NYNEX

Eugene A. Feher

Alvin Fu

Rebecca George, MasterCard

Laura Good, Intel

Vice President Albert Gore

Steve Gray

Sheila Griffin, Motorola

Gilbert M. Grosvenor, National Geographic Society

Kristin Hall, Media Lab

Bob Guccione, Penthouse

Phil Hamlett, Executive Arts

Christie Heffner, Playboy Enterprises, Inc.

Caresse Henry, Maverick

Karen Hersey, MIT

Janet Hill, Scott-Foresman

Ellen Hoffman, Media Lab

Jim Hugunin

John Huikku

Hiroshi Ishii, Media Lab

Penn Jillette, Buggs & Rudy Discount Corporation

Linda Johns, PhotoDisc, Inc.

Yousuf Karsh

Kathy Keeton, GMI

Ken Knowlton

Bernie Krisher

Pat Krolak

David Lewis, Kodak

Andrei Lloyd, The Stock Market

George Lucas, Lucasfilm Ltd.

Greg Lugliani, Names Project Foundation

Madonna

Steve Mann

Loni Marshall, Dahlin Smith White

Gail Mazin, The Stock Market

Betty Lou McClanahan

Steve McGeady, Intel

Peter Menzel

Valerie Eames Minard

Rich Miner, Wildfire

Arno Minkkinen

Eugene Miya, NASA

John Mousseau, MasterCard

Maura Mulvihill, National Geographic Society

Joan Musgrave, IBM

Graham Nash, Nash Editions

Michael Naumann, Henry Holt and Company

Nicholas Negroponte, Media Lab

Kay Nishi, ASCII

Maggie Orth

Jim Page, Motorola

Mimi Park, *Life*

Lucy Petermark, Toppan

Peter Petrinovic, American Greetings

R. Poor

James Robertson, Names Project Foundation

H.B. Siegel, Lucasfilm Ltd.

Wilma Simon, *Geo*

Mark Stutzman, Eloqui

Tom Super, NYNEX

Teller, Buggs & Rudy Discount Corporation

Rebecca Theim, Playboy Enterprises, Inc.

Natasha Tsarkova

Manish Tuteja

John Underkoffler

Nicholas Utton, MasterCard

Jeff Walz, Intel

Lucy Autrey Wilson, Lucasfilm Ltd.

Suzanne Worgul, The Stock Market

Kenneth A. Youngstrom

Robert Zich, Library of Congress

ORGANIZATIONS

ASCII

Buggs & Rudy Discount Corporation

Disney

Eloqui

Executive Arts

Geo

Graceland

Halfcourt Pictures

Henry Holt and Company

Hewlett Packard, Inc.

IBM

Intel

Kodak

Library of Congress

Life

Lucasfilm Ltd.

MasterCard International

Material World Foundation

Maverick

Motorola

Names Project Foundation

NASA

Nash Editions

National Geographic Society

NYNEX

Ogilvy & Mather

PhotoDisc, Inc.

Playboy Enterprises, Inc.

Stock Market Photo Agency

Toppan

United States Postal Service

Wired

Very special thanks to all the family, friends, and sponsors of the MIT Media Laboratory, where this work was born.

PERMISSIONS

pages vi–vii: SEEING THE WORLD THROUGH PICTURES

Composite image is based on a 1969 NASA photograph of Earth. Component tiles are from the author's image database. The text is from a 1994 letter from Arthur C. Clarke.

pages x–xii: INTRODUCTION

The original of Arcimboldo's *Vertumnus* (page xi) is in the collection of the Louvre. The cover of *Wired* (page xii) copyright © 1996 by Wired Magazine Group Inc. Used by permission.

pages xviii–5: OWL

Composite image is an original creation of the author. Component tiles are from the author's image database.

pages 6–7: MARILYN IN LIFE

Composite image is the November 1996 cover of *Life* magazine's sixtieth anniversary issue. Component tiles are earlier covers of *Life* magazine. All images copyright © by *Life* magazine. Used by permission.

pages 8–9: ELVIS PRESLEY

Composite image is based on a portrait of Elvis Presley by Mark Stutzman; adapted by special permission. Component tiles are copyright © by the United States Postal Service. Used by permission.

pages 10–11: LIBERTY

Composite image is based on a photograph of the Statue of Liberty by Richard Berenholtz. Component tiles are photographs from the Stock Market Photo Agency's *American Mosaic*℠ catalog. All images copyright © 1996 by the Stock Market Photo Agency. All rights reserved. Used by permission. Text courtesy of Young Audiences/New York. Used by permission.

pages 12–15: LINCOLN

Composite image is based on a photograph of Abraham Lincoln by Mathew Brady. This photograph and the photographs used as component tiles are from the American Memory Project at the National Digital Library of the Library of Congress, Washington, D.C. Used by permission.

pages 16–17: CHRIST

Composite image and component tiles are from the author's image database.

pages 18–21: 10/10

Composite image and component tiles are from the author's image database.

pages 22–25: JEROME WIESNER

Composite image is based on a copyrighted photograph by Yousuf Karsh; adapted by permission of the photographer and Woodfin Camp and Associates. Component tiles are from the author's image database.

pages 26–29: VINCENT VAN GOGH

Composite image is based on Vincent van Gogh's *Self-Portrait*, 1888, Fogg Art Museum, Harvard University. Component tiles are from the author's image database.

pages 30–31: STARRY NIGHT

Composite image is based on Vincent van Gogh's *Starry Night*, 1889, the Museum of Modern Art, New York. Component tiles are from the author's image database.

pages 32–33: FLAMINGO

Composite image and component tiles are from the author's image database.

pages 34–35: SHUTTLE

Composite image and component tiles are from the author's image database.

pages 36–41: DARTH VADER and YODA

Composite images, component tiles, and text are trademarked and copyright © 1997 by Lucasfilm Ltd. All Rights Reserved. Used Under Authorization. COURTESY OF LUCASFILM LTD.

pages 42–43: AMERICAN GOTHIC

Composite image is based on Grant Wood's *American Gothic*, 1930, the Art Institute of Chicago. Component tiles are from the author's image database.

pages 44–45: DOLLAR BILL

Composite image is based on the $1 U.S. Federal Reserve note. Component tiles are from the author's image database.

page 46: GEORGE WASHINGTON (ANALOG)

Composite image is based on a detail from the $1 U.S. Federal Reserve note. Component tiles are from the author's image database.

page 47: GEORGE WASHINGTON (DIGITAL)

Composite image is based on a detail from the $1 U.S. Federal Reserve note. Composite image and component tile images are the property of MasterCard International and are used by permission. Copyright © 1997 by MasterCard International.

pages 48–49: BILL GATES

Composite image is based on a photo by the author. Component tiles are from the author's image database. Text is from *Programmers at Work*, by Susan Lammers, published by Microsoft Press, 1989.

pages 50–51: MISHRI

Composite image, component tiles, and text are from *Women in the Material World*, copyright © 1996 by the Sierra Club. Used by permission.

pages 52–55: MATERIAL GIRL

Composite image is adapted by special permission of Madonna. Component tiles are from *Material World: A Global Family Portrait*, copyright © 1994 by the Sierra Club, and *Women in the Material World*, copyright © 1996 by the Sierra Club. Used by permission. Text is from a letter to the author.

pages 56–59: THE FLOWER CARRIER

Composite image is based on Diego Rivera's *The Flower Carrier*. The original painting, *The Flower Carrier*, 1935, by Diego Rivera, is in the collection of the San Francisco Museum of Modern Art. Component tiles are from the author's image database.

pages 60–61: JEUNE HOMME NU

Composite image is based on Hippolyte Flandrin's *Jeune Homme Nu*, 1884, in the Louvre. Component tiles are from the author's image database.

pages 62–65: MONA LISA

Composite image is based on a detail from Leonardo da Vinci's *Mona Lisa*, 1503–1506, in the Louvre. Composite image is used by permission of TOPPAN Printing Co., Ltd. Component tiles are from TOPPAN MediaPress™; images courtesy of Eidai Corporation, INAX Corporation, Koizumi Sangyo Corp., Matsushita Electric Works, Ltd., Sankyo Aluminum Industry Co., Ltd., and TOTO Ltd.

pages 66–67: L'ECOLE DU FONTAINEBLEAU

Composite image is based on the original painting in the Louvre. Component tiles are from the author's image database.

pages 68–69: MARILYN/NUDE

Composite image is based on a photograph by Tom Kelley, copyright © 1953 by *Playboy*. Reproduced by special permission of Playboy Enterprises. Component tiles are from the author's image database. The text is from *Marilyn, Mon Amour*, by André de Dienes, published by St. Martin's Press, 1985.

pages 70–73: LA GRANDE JATTE

Composite image is based on Georges Seurat's *La Grande Jatte*, 1886. The original painting is in the Helen Birch Bartlett Collection at the Art Institute of Chicago. Component tiles are from the author's image database.

pages 74–77: AIDS MEMORIAL QUILT

Composite image is based on a photograph by the author. Component tiles are from the AIDS Memorial Quilt, used with permission of the NAMES Project Foundation.